IMAGES
of America

SCARBOROUGH
IN THE
TWENTIETH CENTURY

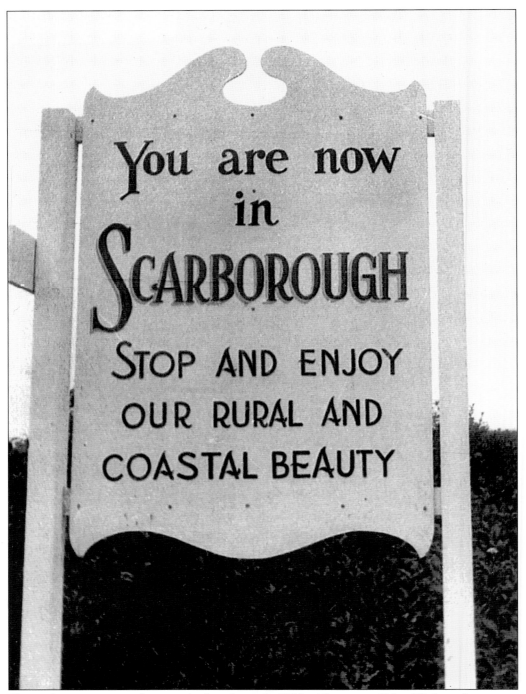

This welcome sign was photographed in the early 1950s. (Courtesy of Lloyd Roberts.)

IMAGES
of America

SCARBOROUGH
IN THE
TWENTIETH CENTURY

Rodney Laughton

ARCADIA
PUBLISHING

Published by Arcadia Publishing,
Charleston SC, Chicago IL, Portsmouth NH, San Francisco CA

Printed in the United States of America

Library of Congress Catalog Card Number: 2004102283

For all general information, contact Arcadia Publishing:
Telephone 843-853-2070
Fax 843-853-0044
E-mail sales@arcadiapublishing.com
For customer service and orders:
Toll-free 1-888-313-2665

Visit us on the Internet at www.arcadiapublishing.com

Seen is the official town seal of Scarborough.

CONTENTS

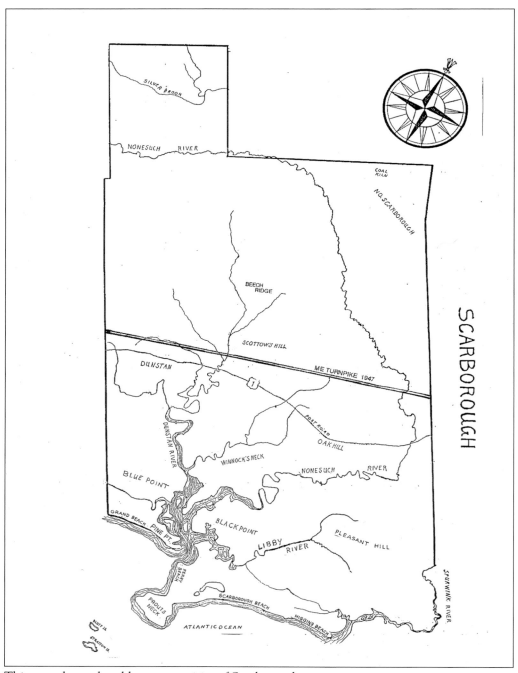

This map shows the older communities of Scarborough.

INTRODUCTION

The story of Scarborough in the 20th century is one of dramatic change. When the century opened, the economy was based on agriculture and seasonal tourism. Scarborough was considered rural. Many families lived on farms or in a village setting. They produced many of the goods that were needed to sustain themselves on a daily basis. In 1900, the vast majority of Scarborough residents had neither electricity nor indoor plumbing. Telephone service had not been introduced, and automobiles were a novelty for the wealthy. In contrast, residents today depend on others for the goods and services they need. Communication and technological advances have surpassed the expectations of the early pioneers in those fields.

In this book, Scarborough in the Twentieth Century, I have gathered a collection of photographs that look back at some of the people and events that laid the groundwork for the community we live in today. It is impossible in 128 pages to cover all the important events or to speak of all the important people who made an impact during the past century. This book was written not to dwell on the past but to reflect and learn about where we have been so that we can look ahead to the future.

Scarborough's location, on the south coast, put the town in the record books for explosive growth. While some towns in Maine have declined or kept nearly the same population over the past few decades, Scarborough has grown by thousands. The population in 1900 was 1,865. In 2000, it was 17,000. It is projected to increase in the future. Scarborough led the state in housing starts in the last quarter-century. Most of the change that has taken place in Scarborough has been driven by advances in transportation. Passenger rail service brought the tourist trade, and by 1900, summer hotels were flourishing. Trolley service was introduced in 1902, opening the door to day travelers and the first commuters, who lived here but worked in Portland. In 1928, the Greater Portland Municipal Airport was constructed on the site now occupied by the Scarborough Industrial Park. This was the golden age of aviation. The nation was fascinated by Charles Lindbergh and his flight across the Atlantic in the Spirit of St. Louis. With the introduction of the automobile, Route 1 became Scarborough's main street. In 1947, the Maine Turnpike opened and in a sense divided the town along a north–south line. All of these changes demanded an infrastructure of support that has sustained the town's economy.

The production of this book and of Scarborough, my previous Arcadia book, is the result of a hobby I started 25 years ago. In Scarborough in the Twentieth Century, I intentionally tried not to cover any people or places that were in the first book. Local history is interesting because it is all around us on a daily basis. Most people have a few old pictures or a story to tell, and that is our heritage. No resident or visitor is insignificant. The interaction of people and the decisions of our businesspeople and political leaders have made this town one of the most popular places in the state of Maine. I hope you enjoy this book as much as I enjoyed putting it together.

—Rodney Laughton
January 2004

ACKNOWLEDGMENTS

I would like to thank Peter Bachelder, a historian with strong Scarborough ties, for the tremendous support he offered. I also extend my thanks to current or former Scarborough residents Warren and Anna Delaware, Roger and Becky Delaware, Ann Googins, Frank Hodgdon, Robert Domingue, Jim and Edna Leary, Jane King, Ken and Maudie Libby, Margery Fancy, Vernon Paulson, William Bayley, Linda McLoon, Jerry Paradis, and my wife, Patricia Laughton.

I am very grateful for the support I received from Leo Boyle, aviation historian; Richard Fraser, automobile historian; Dan Blaney, Old Orchard historian; and Earle Shettleworth at the Maine Historic Preservation Commission.

In addition, my thanks go to the following societies, libraries, and agencies: Scarborough Historical Society, Maine Historical Society, Scarborough Public Library, Portland Public Library, Maine Department of Transportation, Maine Turnpike Authority, and Portland Water District.

I am grateful to staff members at Innes Photo Service of Scarborough for their professional care of vintage photographs that I took there for reproduction.

Finally, there are many other people who took time to speak with me or to supply me with a name, date, or other information. To them I am also grateful.

The images in this book are from my own collection unless otherwise noted.

One

BUSINESSES, LARGE AND SMALL

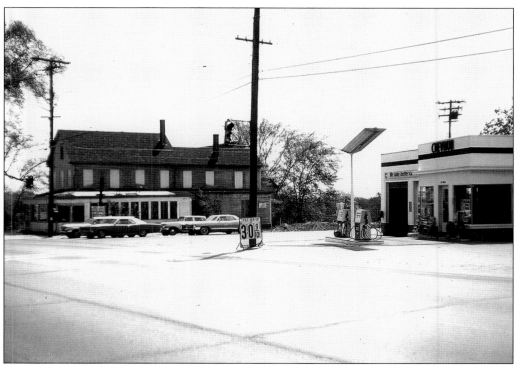

Gasoline was 30¢ a gallon at Bob Jensen's Chevron station when this picture was taken in the mid-1960s. Amato's now occupies this prime location at the Oak Hill intersection. On the opposite corner, the Oak Hill Lodge stands in its last days, boarded up and soon to be torn down. The Mobil Mart is now located on that site. (Courtesy of Larry Jensen.)

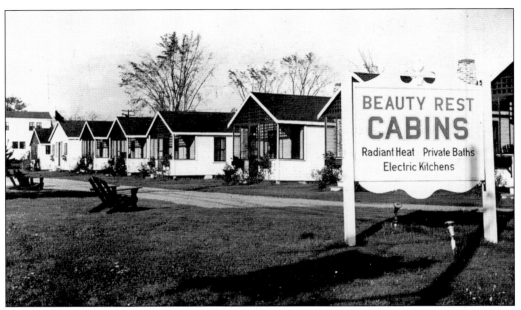

In the 1920s, cabins became popular with working-class members of the traveling public. With the mass production of automobiles and improved working conditions, which included vacation time, more Americans took to the roadways. Now, hotels did not have to be near train stations. Roadside businesses of all types flourished. Scarborough had more than 40 cabin establishments, most of them along the Route 1 corridor. Operated by the Fielding family, Beauty Rest Cabins were located near Pleasant Hill Road on Route 1 (above). Sunrise Cabins were at Oak Hill where Burger King is now located (below). Note the sign advertising the rates.

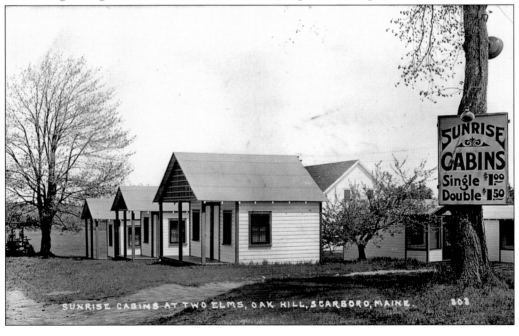

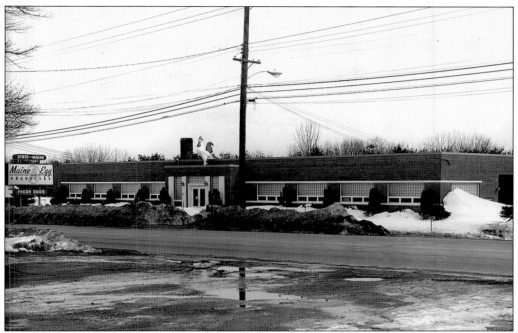

Maine Egg Producers was a clearinghouse and packing plant for locally produced eggs. This plant was built in 1956 by A. S. Treworgy at 136 Route 1, near the Maine Medical Center complex. The plant was state-of-the-art when it opened. Eggs from area poultry houses moved on conveyor belts. They were graded and packed in a cooling room that was maintained at 50 degrees, a temperature that helped preserve freshness. Here, men load trucks on a loading dock that was enclosed in the building (below). This building became a state police barracks for a number of years. Today, it is professional office space. (Courtesy of John Thurlow.)

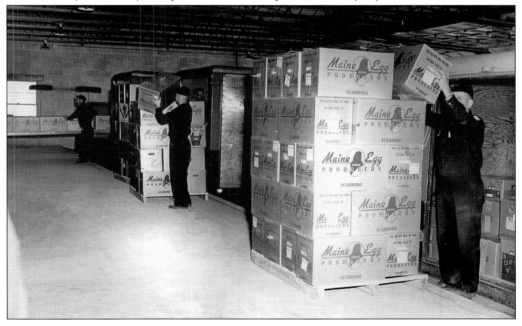

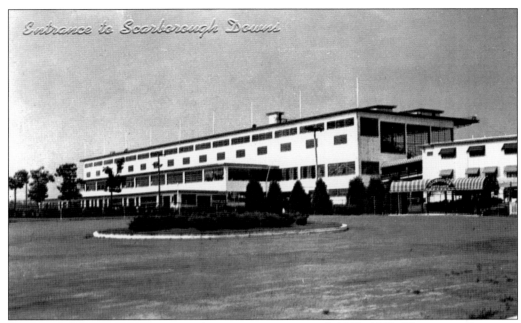

Scarborough Downs was constructed over a two-year period, 1948–1949. The racetrack project was opposed by area merchants, church groups, newspapers, and agricultural fair associations. The two principal contractors were Robert Verrier of Windham, who built the structures, and Joseph Cianchette of Pittsfield, who did the site work. The project did not proceed as planned, and the contractors spent two years in court battling each other. Verrier emerged as principal owner. The one-mile oval opened in 1950. It never achieved the financial success that was anticipated. Without the expected profits, maintenance and improvements were minimal, and in time, wear and tear began to show in the appearance of the buildings and grounds. Harness racing was introduced in 1969, and the track length was reduced to a half-mile.

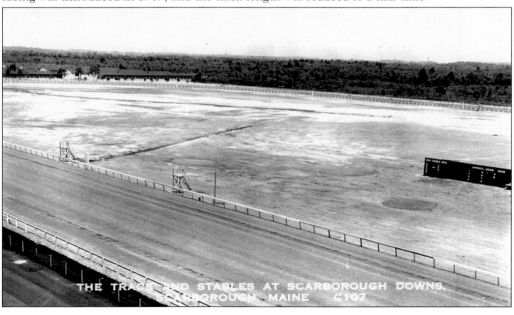

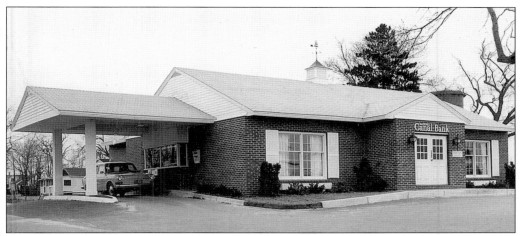

In the early 1960s, a group of business leaders solicited several Portland banks to establish a branch in Scarborough. Canal National Bank was the first to come, locating in the Mammoth Mart shopping complex. In 1970, the town approved a new shopping center (K-Mart) on Route 1. This news, combined with a robbery, helped Canal management decide to move to Oak Hill. The new freestanding bank building proved to be a more central and visible location (above). It is now home to Amato's Sandwich Shop. Three town councilors and the town manager participate in a January 1971 ribbon-cutting ceremony for Casco Bank and Trust, across the Oak Hill intersection (below). From left to right are Oscar Teravainen, Robert Steele, Norman Bushey, Ralph Lorfano, and an unidentified bank official. This bank is now the home of Oscar G's Ice Cream. (Courtesy of Town Archives.)

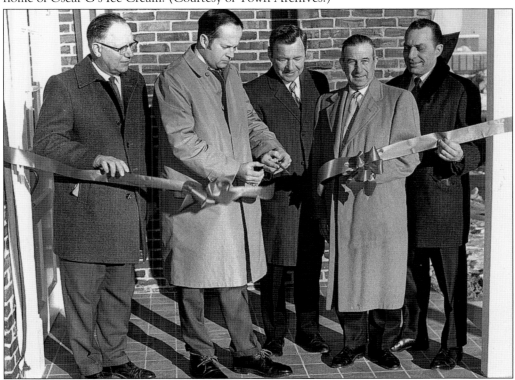

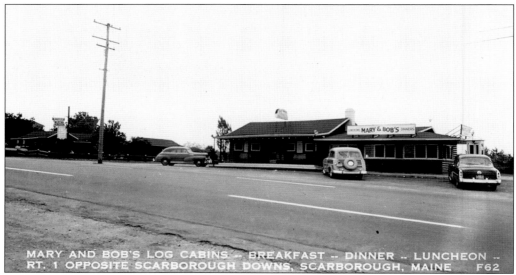

MARY AND BOB'S LOG CABINS -- BREAKFAST -- DINNER -- LUNCHEON --
RT. 1 OPPOSITE SCARBOROUGH DOWNS, SCARBOROUGH, MAINE F62

Mary and Bob's Log Cabin was a popular Route 1 restaurant. Mary and Bob Stough purchased the establishment opposite the entrance to Scarborough Downs in 1941. It became a favorite for high-school students, state police, and others. Civic groups had banquets and meetings there on a regular basis. Shown in its early years (above), the restaurant grew to have 99 seats. Mary Stough tells the boys how things should be in 1958 (below). From left to right are the following: (front) Allen Durgin; (back) Bob Nutter, Harry Hughes, and Clark Libbey. Business suffered when Route 1 became a divided highway in the early 1970s. Mary Stough retired, and shortly afterward, a fire consumed most of the building. St. Nicolas Episcopal Church is now located on the site. (Below, courtesy of Alan Durgin.)

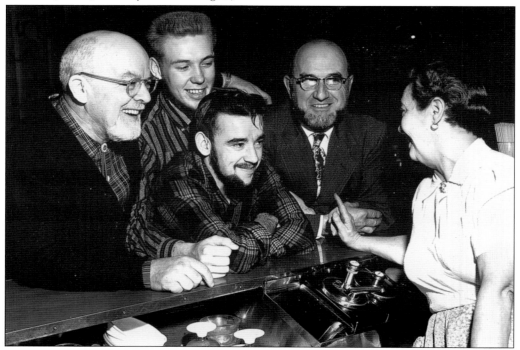

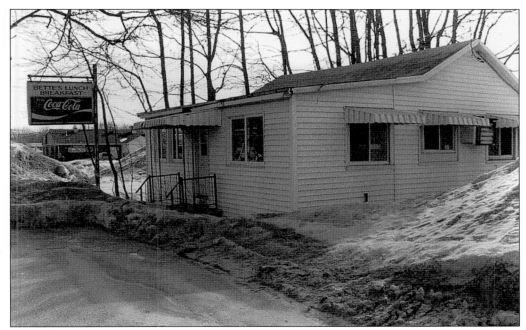

For nearly 50 years, Bette Pennell served breakfast and lunch in her roadside Oak Hill establishment—a classic one-room, one-woman New England grill. The roadside stop was gathering place for locals. Topics such as the Red Sox and politics were often discussed over hearty breakfasts or the grill's signature cheeseburgers. Bette Pennell put the coffee on at 4:00 a.m. and worked 365 days a year. She possessed the legendary Yankee work ethic.

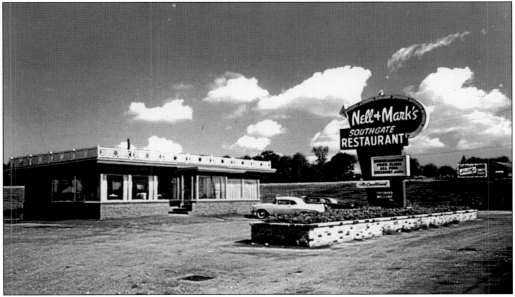

Nell and Mark's Southgate Restaurant was near the marsh, south of Oak Hill, on Route 1. During the 1950s, restaurant names such as Nell and Mark's, Roy and Judy's, and Mary and Bob's were very popular in Scarborough. The proprietors of this business were Ernell and Sylvio Marquis. American Cafe now occupies this location.

For more than 30 years, Libby's Toy Shop was a mecca for Scarborough children. Erroll and Corrine "Peachy" Libby started the business in the barn of their home at Oak Hill in the early 1940s. Erroll Libby kept building on until there were 11 rooms of toys. After the business closed, the main house was moved away. What remains on site is now occupied by Brown Fox Printing and New Angles Hair Salon. (Courtesy of Susan Libby.)

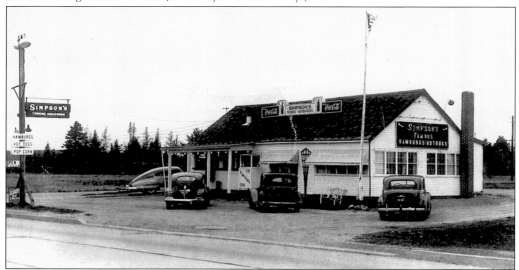

Simpson's Famous Hamburgers was a classic roadside drive-up establishment. It was started by Harold Simpson in a building that had formerly been Burnell's Restaurant. Simpson's was "fast food" in its day, an era when meals were hand prepared and the owner was in the store. Business slowed after Route 1 became a divided highway in that area, and Harold Simpson sold the property. Eventually, the building was torn down. Today, the office of Dr. Stephen Mills, a pediatric dentist, occupies the site. (Courtesy of Peter Bachelder.)

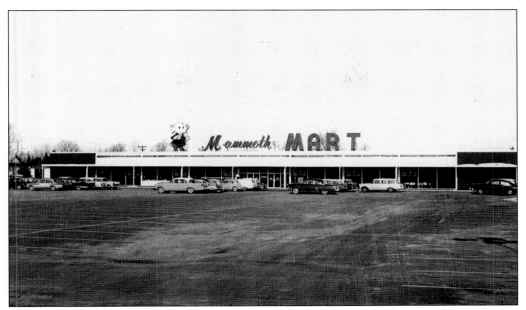

The Mammoth Mart was Scarborough's first department store. Built by a Massachusetts development firm in the early 1960s, the store was pale in comparison to Wal-Mart, but it was the same concept. A grocery store and several other small businesses were located in the same strip development. The site, at 301 Route 1, has been redeveloped into a nonretail business complex known as the Orion Center.

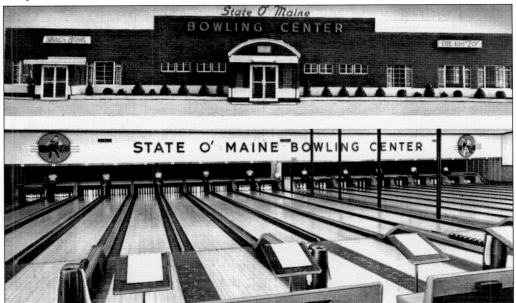

The sign out front reads, "State O' Maine Bowling Center," but the place has always been called the Big Twenty since it opened in 1950. At that time, it was billed as "Maine's largest and most modern bowling center." It had 20 candlepin lanes, equipped with automatic pinsetters, a soda fountain, and a snack bar. Located on Route 1 near Haigis Parkway, it was built by A. S. Anton, whose son Chris Anton is now the proprietor.

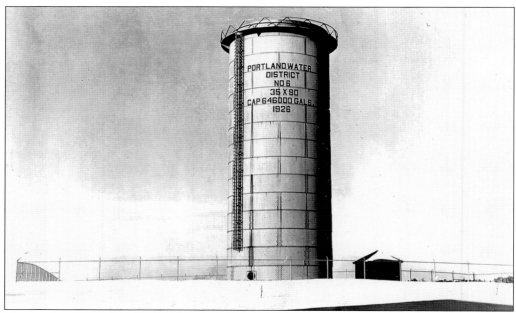

The Portland Water District built this tower at Oak Hill in 1926. The district also had towers at Prouts Neck and Dunstan. The towers helped regulate water pressure in the main lines. Of the three towers mentioned, only this one remains. (Courtesy of Portland Water District.)

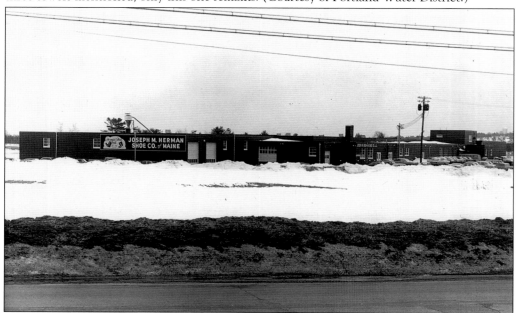

The Herman Shoe Company was the first light industry to open in the industrial park opposite what is now Haigis Parkway. The shoe factory opened in 1960 and at one time employed more than 300 workers. The parent company was founded in 1879 in Millis, Massachusetts. It specialized in high-quality boots and work shoes. The company produced government-issue army boots and the official Boy Scout shoes. This location closed in 1986. (Courtesy of Town Archives.)

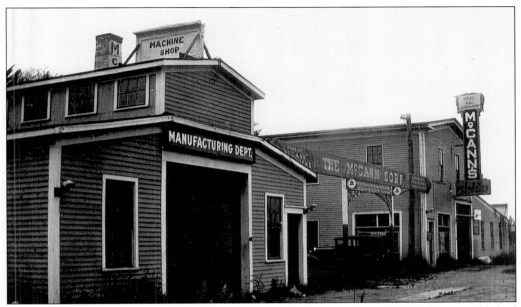

The McCann Fire Truck Company moved from Portland to Scarborough in 1931. It established a manufacturing plant on Route 1. A basic chassis entered the manufacturing door (left), and a completely finished fire truck emerged under the vertical McCann sign. The factory closed in the early 1950s, and eventually the buildings were consumed by fire. Some 250 McCann trucks are still in existence across the country. The 1938 pumper (below) is in the Portland Fire Museum. Ironically, the Scarborough Fire Department never owned a McCann truck. Soon, on the McCann site, a Mercedes dealership is scheduled to be built. (Courtesy of Elizabeth McCann.)

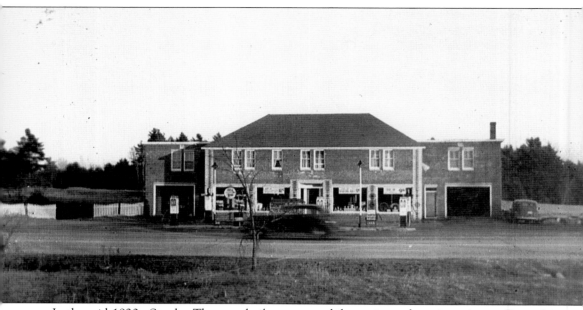

In the mid-1920s, Stanley Thurston built an automobile service and repair station on Route 1 in Dunstan. The business included a showroom on the first floor for new cars and sleeping rooms upstairs for long-haul truckers, who worked for a company called University of Overland (later, Overland Express). The home of the author's father, Kenneth Laughton, was across the highway. At about age 14, he earned an A for writing the following school paper, entitled "How I Earned Some Money": "Last spring a filling station was built across the street. The man, who built the place, asked if I would like to work for him during the summer. I said that I would and began the next week. I had to open at six and work until five thirty. I had to pump gas and oil, change tires, drain the crank case and other things. I worked nine weeks and three days, and missed one half day. During an hours nooning (lunch hour) I picked one or two quarts of berries and sold them at the filling station." In the late 1940s, Vernon Paulson purchased the building and based his cabinetmaking business there. The building looks much the same today as it did when this photograph was taken in the late 1930s.

Pride Motel and Cottages began as Pride's Cabins in the 1920s, with owners Ed and Etta Pride. The Prides' son Henry carried on the family business for a second generation. The old homestead is shown with trolley tracks in the foreground (above). By the 1950s, the barn had been removed and cottages had taken its place (below). Today, Patrick and Sue O'Rieley own the 10-cottage, 7–motel unit business. The cottages are a fine example of this once popular type of roadside accommodation. A swimming pool and other present-day amenities show the business has adapted to appeal to today's traveling public.

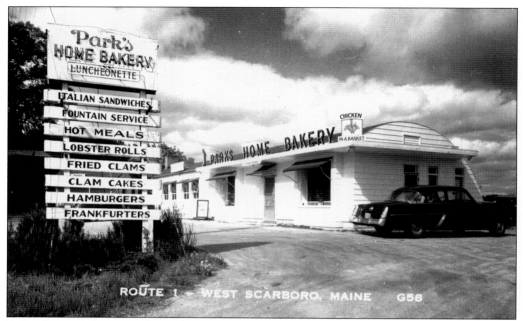

Parks Home Bakery was located on Route 1 in Dunstan near the Saco line. The restaurant and bakery were housed in a Quonset hut—one of the structures produced by the navy during World War II in Quonset, Rhode Island, and sold as surplus after the war for about $1,000 each. The classic 1950s interior of Parks Home Bakery (below) would be a popular spot if it were still in existence. The Quonset hut was removed long ago, and a new building was erected on the site by Furniture Showplace.

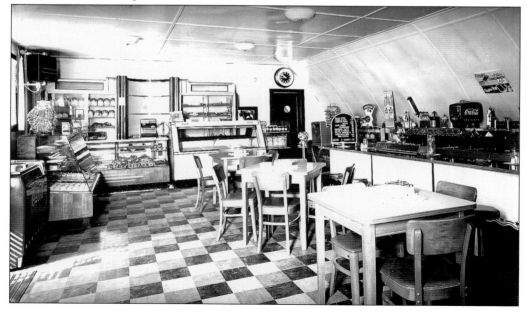

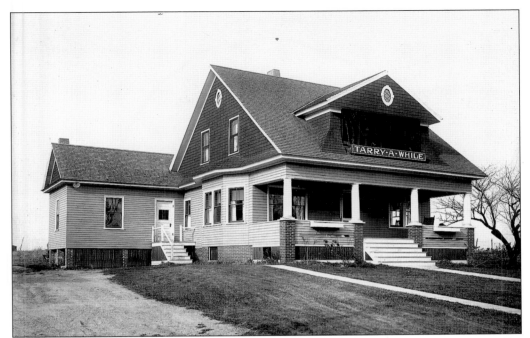

The Tarry-A-While was a seasonal shore-dinner establishment in Dunstan. It was operated by Frank and Arlene Leary. The Learys lived in a small home next to the restaurant. No longer a business, the Tarry-A-While still stands as a private home next to Engine 6 Fire Station. (Courtesy of Mary Lello.)

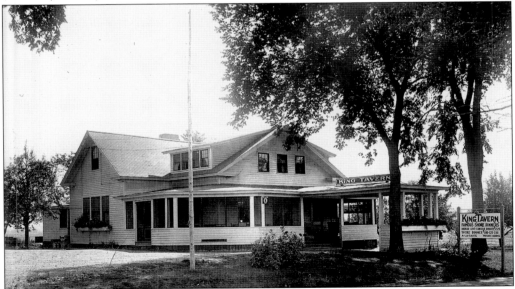

King Tavern was a shore-dinner house on the Dunstan Landing Road. It first opened for business c. 1923. The establishment took its name from its proximity to the birthplace of Rufus and William King. The brothers were prominent political figures in American history. King Tavern, after a change of ownership, was known as Squando Lodge. It was eventually closed, and the building was torn down.

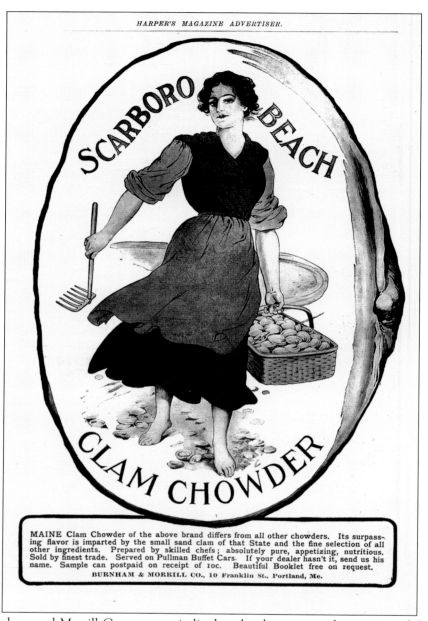

MAINE Clam Chowder of the above brand differs from all other chowders. Its surpass-ing flavor is imparted by the small sand clam of that State and the fine selection of all other ingredients. Prepared by skilled chefs; absolutely pure, appetizing, nutritious. Sold by finest trade. Served on Pullman Buffet Cars. If your dealer hasn't it, send us his name. Sample can postpaid on receipt of 10c. Beautiful Booklet free on request.

BURNHAM & MORRILL CO., 10 Franklin St., Portland, Me.

The Burnham and Morrill Company capitalized on local resources when it canned Scarboro Beach clam chowder and then promoted the product with magazine advertisements. This advertisement dates from the early 1900s, long before radio and television. The Portland-based company canned a variety of meat, vegetable, and fish products. In the early 1900s, small-scale Burnham and Morrill canneries were scattered throughout Maine and the Maritime Provinces, including a clam-canning facility at Pine Point. At Back Bay in Portland in 1913, the company built a four-story plant (visible from Interstate 295 near the Falmouth line) and gradually phased out its smaller canneries. After World War II, the company concentrated its efforts on canning New England baked beans and related products. They are marketed nationally under the B&M label.

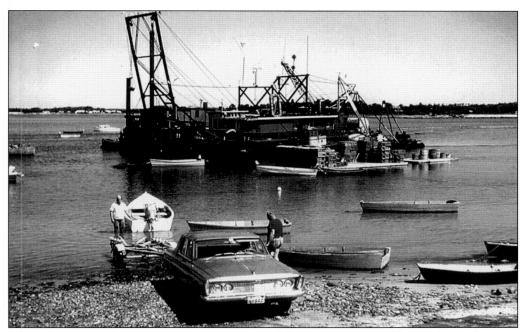

The Army Corps of Engineers has overseen several dredging projects in the Scarborough River. Without dredging, the channel is so shallow that commercial and recreational boaters are severely limited in access. This dredge took place in 1966. (Courtesy of Mary Louise Record.)

Commonly called the Co-op, the Pine Point Cooperative Association was formed in 1947 by local fishermen. The fishermen thought that, as a group, they would have greater purchasing power for their fishing supplies. Their original structure, photographed in 1956, was located near the town landing. This building later became a restaurant known as the Poop Deck. (Courtesy of Mary Louise Record.)

In 1952, Ken and Irene Skillings built this seafood takeout on the Pine Point Road. They had actually started the business 20 years earlier on East Grand Avenue. Eventually, they sold the business. A dining room has since been added, and the business has evolved to meet the demands of the dining public. It continues to operate on a seasonal basis with the original name, Ken's Place.

Dance halls were popular social gathering places in the 1930s and 1940s. This one, operated by Olive Carter, was located where Ash Swamp Road branches off from Broadturn Road. Such a fork in the road was commonly called a crotch, and this establishment was well known as Olive's Crotch. After the building was taken down years ago, trees took over the site. The photograph dates from the summer of 1948. (Courtesy of Faye Holmes.)

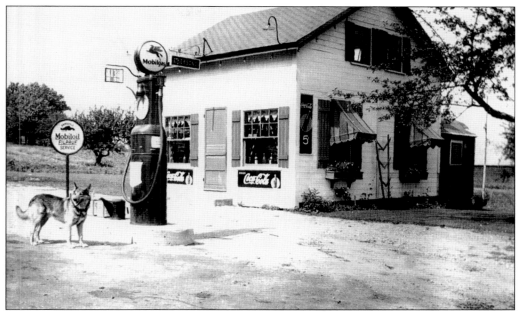

Mert Emerson established this roadside business on Beech Ridge Road not far from his home. Inside, he served food and offered seating for 10 patrons. His family still has some of the advertising signs. One of them reads, "Ham, Eggs and Coffee for 30 Cents." The photograph dates from the late 1930s. The building was later remodeled into a small home. (Courtesy of Faye Holmes.)

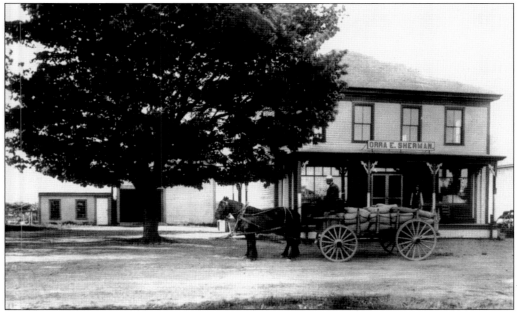

Four generations of the Sherman family operated this store, located near the intersection of Saco Street and County Road in North Scarborough. At the time this photograph was taken, in 1915, Orra Sherman was proprietor. His father had started the business in 1865. The building is now used as a restaurant. (Courtesy of Peter Bachelder.)

GOOD NEWS!!

GANEM'S GENERAL STORE

IS NOW OPEN ON
BROAD TURN ROAD
One-half Mile North of Vinegar Road

CARRYING A FULL LINE OF

MEATS - GROCERIES
NOTIONS - TOBACCO
GRAIN - ICE CREAM
BEER TO TAKE OUT

ITALIAN SANDWICHES MADE TO ORDER

Free Delivery --
Call Scarboro 22-21

Quality - Service - Low Prices is our aim

SCARBORO PRESS

Fred Ganem turned the front room of his house into a variety store. The house was located on the Broadturn Road just north of Holmes Road (at that time known as the Vinegar Road). It had previously been owned by a sea captain named Schofield. Ganem's store offered everything from sandwiches to nails. It was a true variety store until it closed in the late 1970s. Today, it is a private residence once again.

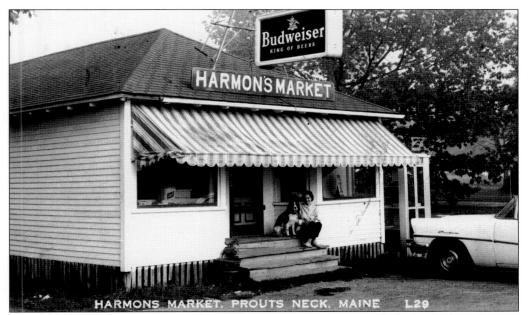

Harmon's Market was located on Black Point Road near Prouts Neck. It was built in the late 1930s by Clint and Olive Harmon as a seasonal fish market. Groceries were added in the mid-1940s, after son John Harmon took over the business with his wife, Thelma (above). The business, now known as White Caps, still operates in the summer season.

Ira Foss, proprietor of the Checkley Hotel on Prouts Neck, purchased this farm in the early 1900s to service his hotel. Known as the Checkley Farm, it was located on the corner of Spurwink and Black Point Roads. A pond was created and a large icehouse built. The farm had Jersey cows for milk and cream, fresh vegetables, and poultry. Eventually, this property was purchased by the Camp Fire organization and became a summer day camp for boys and girls. After the house partially burned, it was taken down. The barn served Camp Fire into the late 1990s, when it too was heavily damaged by fire. A new building has since taken its place. (Courtesy of Beverly Kilton.)

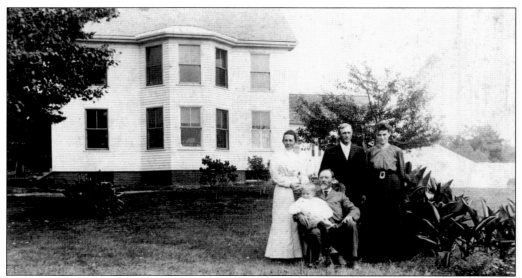

Selius Pederson (1879–1966), whose family had emigrated from Norway when he was young, operated the largest commercial greenhouse business ever established in Scarborough. His home and business were located on Highland Avenue. Highland Avenue Greenhouses now operates on a smaller scale at this location, and the home today looks much as it does here (above). At the height of operation, Pederson maintained 36,000 square feet of glasshouses and did a thriving wholesale business throughout New England (below). He married Amy Cooke of South Standish, and the couple had two children: Stanley, who tragically died in his senior year at Scarborough High School in 1927, and Mary, who became a teacher. When the Pedersons retired, they sold the property and moved to South Standish. There, they opened a poultry business and started raising gladiolas. As a retiree, Pederson raised 20,000 gladiolas annually. (Courtesy of Ann Googins.)

S. E. PEDERSON

...*Florist*...

SCARBORO, MAINE

Telephone 20

SEEDLINGS

100 in Flat at $1.50 per Flat

Ageratum	Petunias, light blue
Annual 'mums	Petunias, dark blue
Asters, mixed	Petunias, Mixed
Bachelor Buttons, mixed	Petunias, Rosy Morn
Bachelor Buttons, blue	Phlox, Drummondi
Calendula, orange	Salvia
Coreopsis, mixed	Salpiglosis
Cosmos, mixed	Scabiosa, mixed
Larkspur, annual mixed	Snapdragon, mixed
Larkspur, annual blue	Snapdragon, pink
Marigold, French	Stocks, mixed
Marigold, Guinea Gold	Zinnia, mixed
Marigold, Josephine	Zinnia, Scarlet
Mexican Firebush	Zinnia, pink
Petunias, California Giant	Zinnia, yellow

12 in a Box - 25c. per Box

Petunia, California Giant	Salvia
Petunia, Rosy Morn	Scabiosa
Petunia, light blue	Snapdragon
Petunia, dark blue	Verbena
Salpiglosis	Zinnia

12 in a Box - 30c. per Box

TOMATOES, John Baer

Shown is Pederson's wholesale price list from the 1920s. (Courtesy of Ann Googins.)

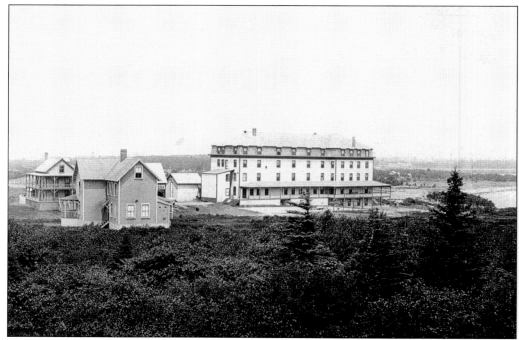

The Jocelyn Hotel, at Prouts Neck, is pictured as it appeared not long after it was constructed in 1890 (above). It had a long boxy appearance, a style that was popular in hotel construction at the time. Seven years later, noted Portland architect John Calvin Stevens was hired to redesign the hotel and give it a Victorian appearance. Close inspection of these photographs reveals how Stevens achieved the desired effect without much disturbance to the original structure. The front of the hotel received an addition with a pitched roof and towers. Tower roofs were also added toward the back on both sides. The hotel burned to the ground in 1909.

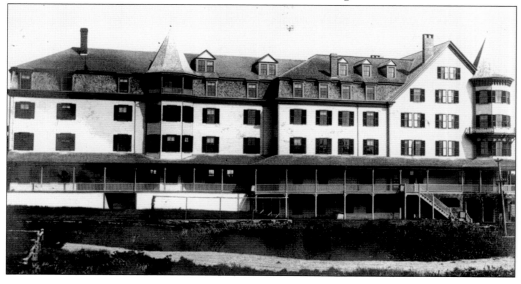

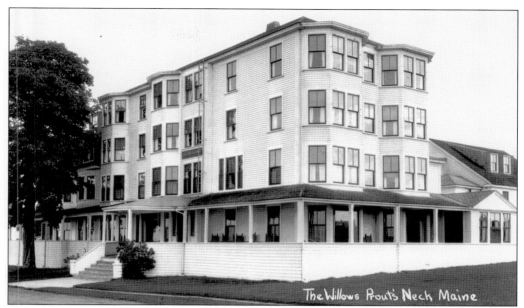

The Willows Prout's Neck Maine

The earliest part of the 20th century saw a tremendous growth in the number of lodging establishments, especially in the Prouts Neck area. By mid-century, these aged hotels began to fall from popularity. In this case, the Willows began as a farmhouse in the 1870s, grew to an 80-room hotel (above), and finally fell to the wrecking ball in March 1965 (below). A private home now occupies the site.

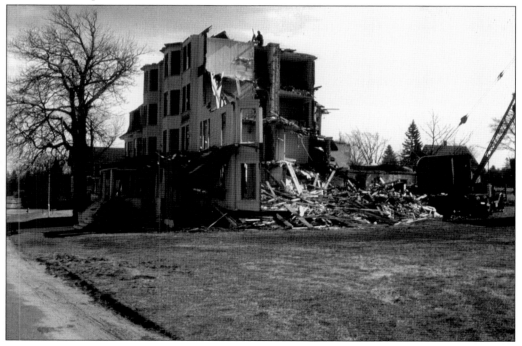

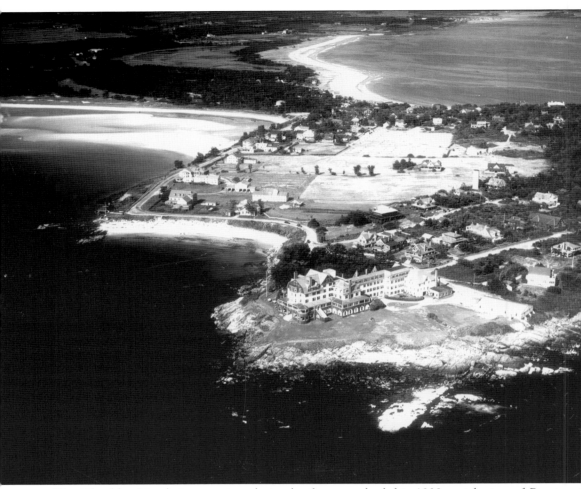

The Checkley Hotel sits prominently in the foreground of this 1939 aerial view of Prouts Neck. It is easy to see the area that was sheep pasture before the peninsula became a popular summer resort. Some 10 years after this photograph was taken, the Checkley was torn down. In the following decades, other hotels along the western shore—the West Point (left), the Cammock, the Willows, and the Lee House—all suffered the same fate. (Courtesy of Aerial Photos International.)

Many of Scarborough's early hotels began as private homes that accommodated tourists and then evolved into full-scale businesses. This was the case with the Higgins Inn at Higgins Beach. Ed Higgins built an eight-room home in 1903. In 1923, the hotel was built as an addition to the house. Note the window configuration and the band of trim between the first and second floors in these two views.

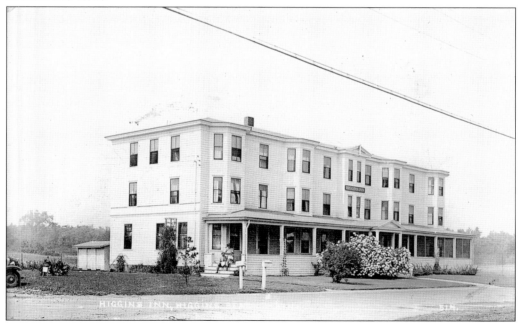

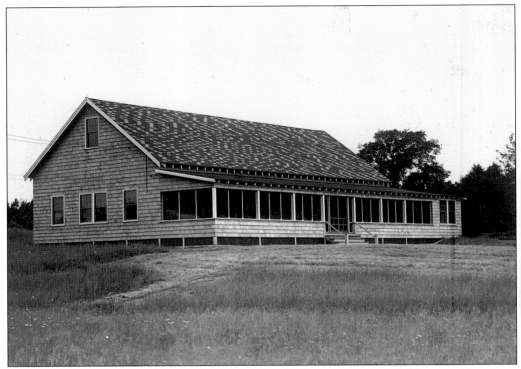

In 1927, the Higgins Beach Improvement Society built a community clubhouse with a stage for theatrical productions, on what is now Kelly Lane (above). When the improvement society (the forerunner of the Higgins Beach Association) failed to pay the investors in a timely manner, the property was sold. Several small cottages were built, and the business was operated as a lodging establishment called the Ledges. Upscale homes are now being built on the property, and these buildings are slated for demolition. Shown is a business letterhead for the property (below). A 1958 Chevrolet is in the foreground.

THE LEDGES

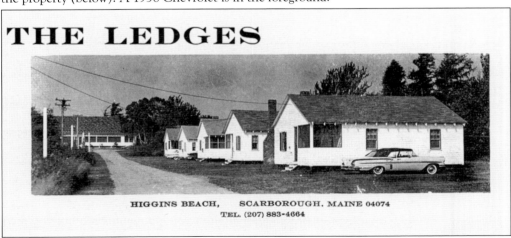

HIGGINS BEACH, SCARBOROUGH. MAINE 04074
TEL. (207) 883-4664

Two

PUBLIC SERVICE

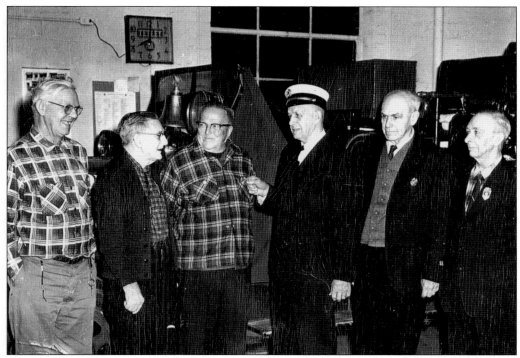

Arthur Snow receives his Gold Badge for 25 years of service to Engine 6 Fire Station, at Dunstan. Chief Henry Gould is making the presentation. Looking on are other Gold Badge members, from left to right, Archie Merrill, Cliff Leary, Ralph Sargent, and Horace Whipple. (Courtesy of Engine 6.)

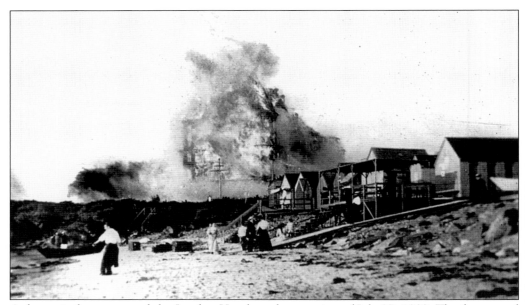

A dramatic fire consumed the Jocelyn Hotel on the morning of July 27, 1909. The fire started in an adjacent property, and lacking an organized fire department, residents could only stand by while the flames spread to the hotel. As a result of the fire, residents began to discuss, and shortly to organize, a volunteer fire department.

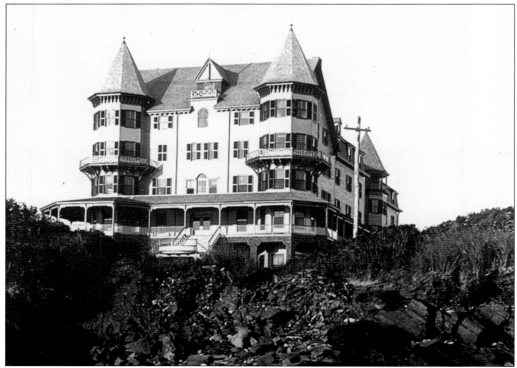

This is a comparison view of the Jocelyn. The hotel was located on Prouts Neck near the Black Point Inn.

In the early days of the fire department, volunteers were alerted by the ringing of this steel wheel. A sledgehammer (right) was used to sound the alarm. These steel wheels were erected at various locations throughout town and were also used as air-raid signals during World War II. One of these wheels, from a train locomotive, still stands outside Engine 3 Fire Station, at Pleasant Hill. The woman in this photograph is unidentified. (Courtesy of Eva Storey.)

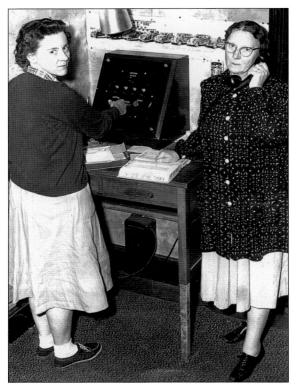

Before the modern era of fire and rescue dispatch, emergency calls were handled by Elizabeth Libby and her daughter Shirley Libby. The two women, who started the community service in 1947, used a Gamewell alarm system. When a call came in, they activated the system, which controlled air horns located at each fire station. They performed the service in a first-floor location that led into the store they operated on Black Point Road. The family residence was located above the store. One of the two women had to be available 24 hours a day. A 1958 newspaper story reported the pair had only been away from their post together twice in the first 11 years of service. Elizabeth Libby (below) receives a plaque at the time of her retirement as dispatcher in 1971. Clayton Urquhart, a founding member of Scarborough Rescue, makes the presentation. (Courtesy of Scarborough Rescue.)

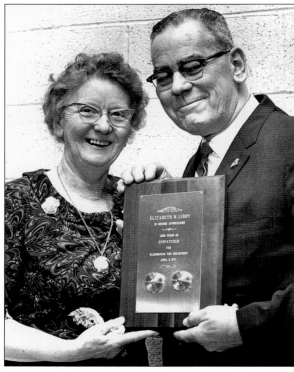

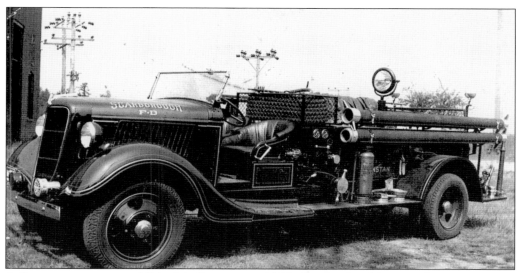

A fire company was established in Dunstan in 1915. For the first 20 years of its existence, it used a hose and cart as a fire apparatus. The first truck was this 1936 Ford. It was housed in the building that is now the Scarborough Historical Society. It had an open cab, and thus, at times firefighters had to battle the elements as well as fires. It was replaced in 1952 by a Maxim. (Courtesy of Engine 6.)

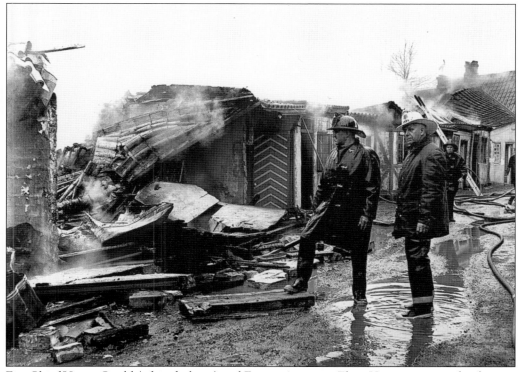

Fire Chief Henry Gould (white helmet) and Engine 1 captain Elver Harmon survey the damage at the Danish Village on April 21, 1968. The fire burned 22 units at this roadside lodging establishment. (Courtesy of Peter Bachelder.)

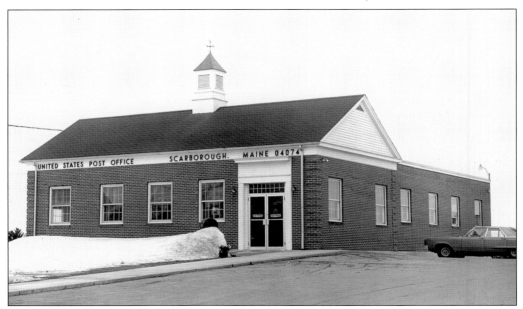

A new post office opened at Oak Hill in 1965 (above). The new central location consolidated two previous post office locations, one in Dunstan and one in Black Point. The post office outgrew this building after some 15 years and moved to its current location on Gorham Road. Now extensively enlarged, the building is home to the law offices of Jones and Warren and other professionals. Rural free mail delivery (RFD) began in Scarborough in 1903. A carrier stops at the foot of Ashton Street at Higgins Beach (below). Before telephone service, mail was a vital communications link. (Below, courtesy of Ann Leavitt.)

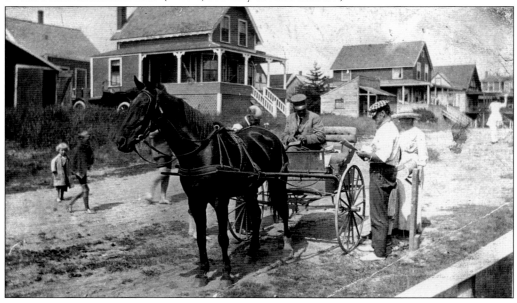

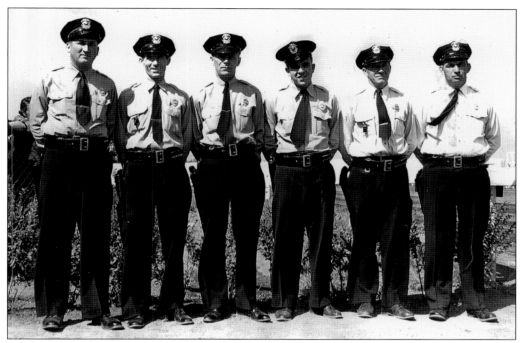

The formation of the Scarborough Police Department coincided with the opening of Scarborough Downs in 1950. Before that time, officers were hired on an on-call basis. From left to right in this 1955 photograph are Kenneth Dolloff, Peter Dennis, Stanley Clark, Richard Collins, Walter Douglass, and Norman Libby. (Courtesy of John Flaherty.)

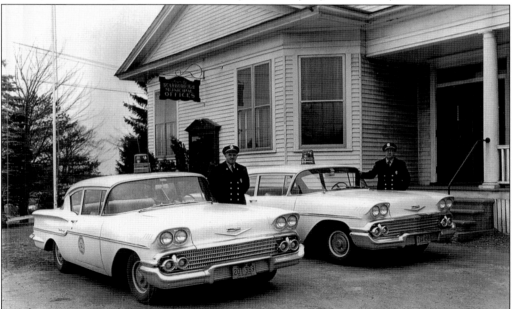

John Flaherty (left) and Police Chief Willis "Bill" Pride stand next to the 1958 Chevrolet cruisers in front of town hall. Pride was Scarborough's first police chief. John Flaherty later served in that capacity. (Courtesy of John Flaherty.)

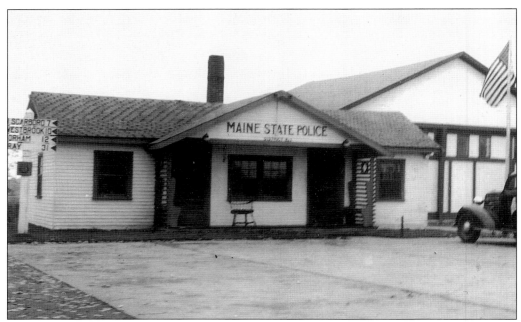

The state police have had a long association with the town of Scarborough that began in the early 1930s. At that time, they built the barracks at Payne Road and Route 1 (above). In 1948, a new brick building was built just north of the old barracks on the opposite side of the road (below). This building is still in existence and is home to a food brokerage firm. The third and final move in Scarborough came in 1974, when the state police rented the former Maine Egg Producers building farther north on Route 1. This location was used for 15 years until a new barracks and communications center was constructed in the town of Gray. (Courtesy of Scarborough Historical Society.)

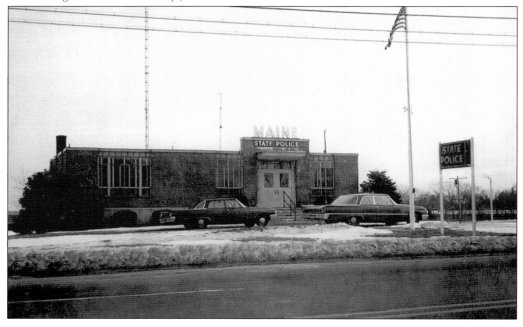

The Maine State Police were organized in 1921. Throughout that decade, troopers rode Harley-Davidson motorcycles. Carl Wibe of Scarborough was on the force at that time. The first cruisers were introduced in the 1930s. (Courtesy of Peter Wibe.)

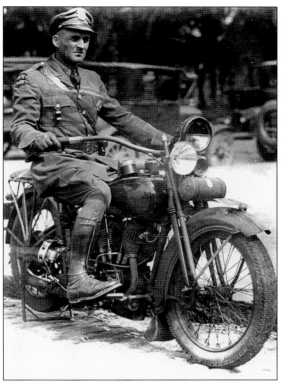

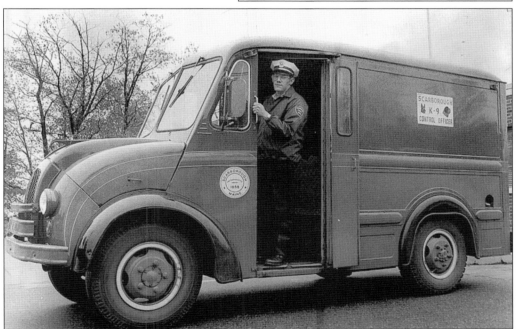

Officer Richard Babine stands in the doorway of the town's first K-9 vehicle, an old home delivery milk truck that had been purchased by the town. The photograph, dated May 29, 1974, was taken in front of Engine 7 Fire Station, at Oak Hill.

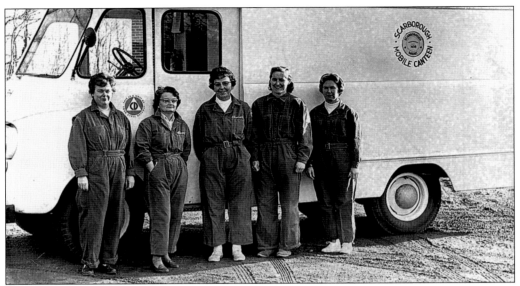

The fire department's mobile canteen unit came into service in 1952. It was founded by Eleanor Lorfano, who served as captain for many years. When fires were of long duration, the canteen provided refreshment. The truck was purchased secondhand with donated funds. This 1968 photograph shows 5 of the 14 volunteer members. From left to right are Barbara Redmond, Maureen Worthing, Eleanor Lorfano, Betty Shorey, and Pat Driscoll. (Courtesy of Scarborough Rescue.)

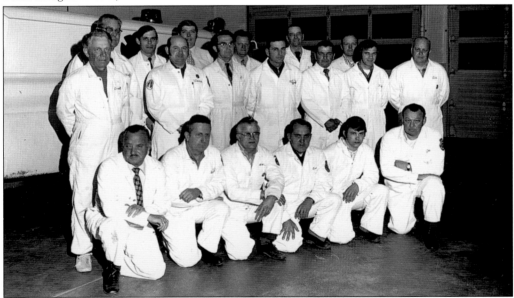

In the early 1970s, the town had a 20-man rescue squad. Present in this group at Engine 7 Fire Station are 19 of them. From left to right, they are as follows: (front) Chet Knight, Bill Fielding, Paul Webster, George Milliken, John Hart, and Joe Houy; (middle) Grant Worthing, Warner Garland, Al Sprague, Clifford Mitchell, Ira Hart, Clifford Knight, and Len Libby; (back) Clayton Urquhart, Paul Beeler, Rev. Kenneth Almeda, rescue founder Dr. Philip Haigis, Ralph Dunton, and Herbert Hughes.

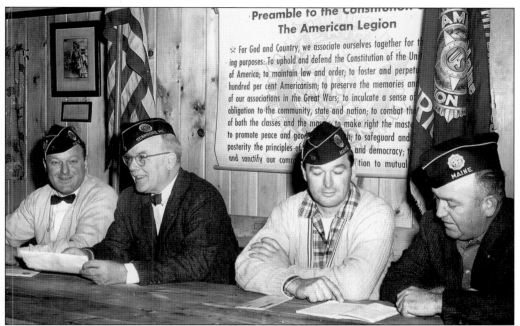

The American Legion established a post in Scarborough after World War I. At that time, it was known as the Lucien T. Libby Post, named for a Scarborough soldier killed in France. After World War II, the name was changed to the Libby-Mitchell Post to honor Donald Mitchell, who was also killed in France. Four past commanders of the post appear in this c. 1964 photograph. From left to right, they are Elvander Coulthard, Robert Nutter, John Coulthard, and Linwood Higgins. (Courtesy of Libby-Mitchell Post.)

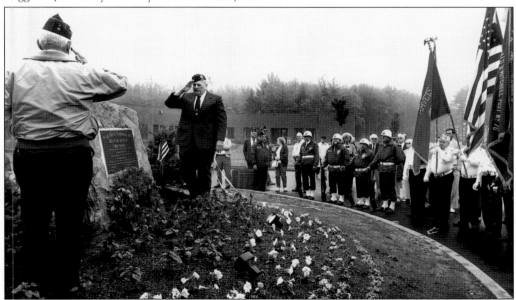

Elwood Mitchell salutes at the dedication of a memorial in front of the Maine Veteran's Home in 1990. The bronze plaque reads, "To The Sons Of Scarborough Who Died In The Service Of Their Country." Mitchell served in World War II.

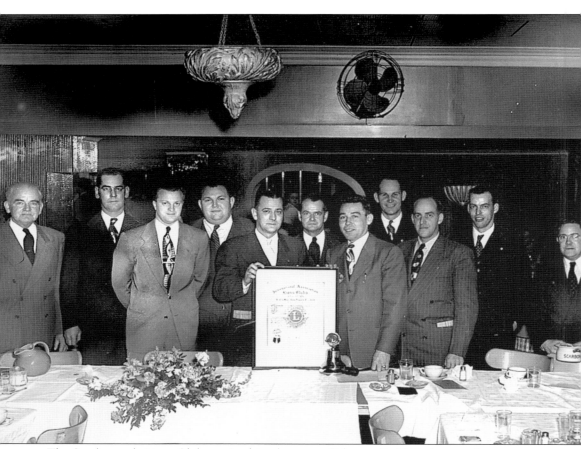

The Scarborough Lions Club received its charter on February 2, 1949. Among those present at Valle's in West Scarborough are, from left to right, unidentified, Clayton Urquhart, Dr. Philip Haigis, Roger Grant, unidentified, Ken Bartlett, Robert Jensen, Jack Conroy, Horace Maxey, Paul Bayley, and Frank Littlehale. With the motto "We Serve," the Lions give back to the community all the funds that are raised. From the beginning, this has been an active group. In 1951, it financed and manned the first municipal rescue unit in the state. It purchased and donated six more rescue vehicles to the town over the past 50 years. It started the Little League program and sponsored Boy Scout Troop No. 39. From helping individuals in need to projects that benefit the general population, this group has enriched the way of life in Scarborough.

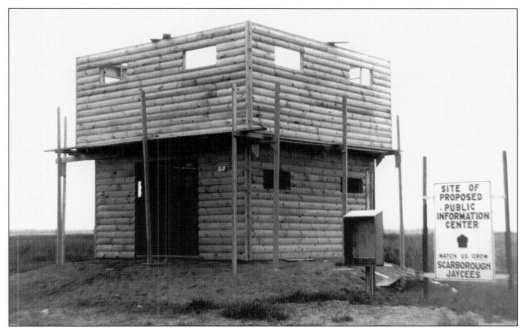

The Scarborough Public Information Center was a project undertaken by the Scarborough Jaycees in 1961. Shown here under construction, it was built to resemble a blockhouse from Colonial times. Located at the halfway point on the Scarborough Marsh, the information center flourished for about 15 years. After the septic system failed, it was forced to close. The building was eventually removed to Smiling Hill Farm in Westbrook. (Above, courtesy of Frank Hodgdon.)

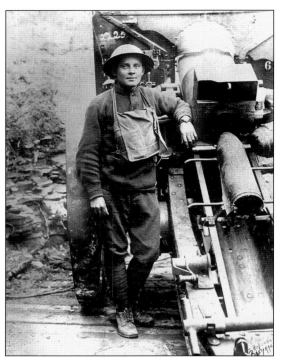

After the death of his son in 1918, Charles E. Libby wrote the following letter to the trustees of the Scarborough Public Library: "It is my wish to make some public memorial for my deceased son, Lucien Taylor Libby, and for that purpose I make the following proposal to you: I will deposit with the Fidelity Trust company, Portland, one thousand dollars, the income thereafter to be withdrawn semi-annually and to be expended by our board for books for the library. The books shall be marked, 'This is a Lucien Libby book.'" Lucien Libby's legacy continues, as books are still purchased with interest from the trust established by his father. Lucien T. Libby is shown on duty during World War I in France (left). Also pictured is the bookplate used by Scarborough Public Library to denote a book purchased in Libby's memory (below). (Courtesy of Scarborough Public Library.)

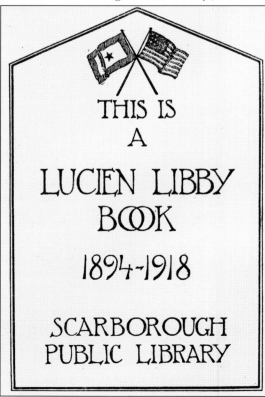

THIS IS A LUCIEN LIBBY BOOK 1894-1918 SCARBOROUGH PUBLIC LIBRARY

Three

TRANSPORTATION

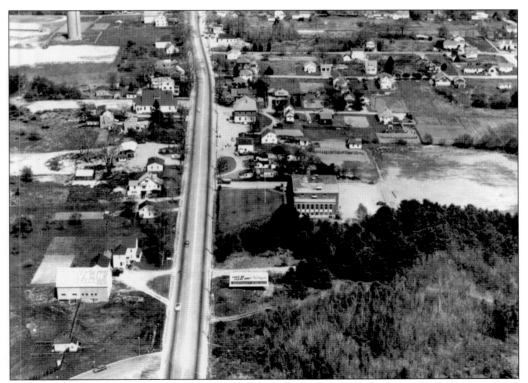

In Colonial times, almost all travel was conducted by boat along the coast. When the railroad was established in the 1840s, it became the major artery through town. With the advent of the automobile, Route 1 became Scarborough's main street (above). This photograph dates from the early 1960s. The wooded area (foreground) is now the site of the Maine Veteran's Home.

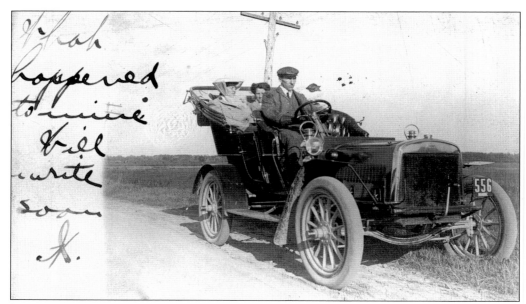

Innovations in transportation were major catalysts for change. Automobiles required better roadways. Trains and trolleys required tracks, and airplanes required runways. The entire community changed, as an infrastructure was built to support the new means of transportation. Business such as restaurants, lodging houses, and service stations were the result. This 1903 Ford was registered to John Meeker, a summer guest at the Atlantic House at Scarborough Beach. (Courtesy of Jack Boyce.)

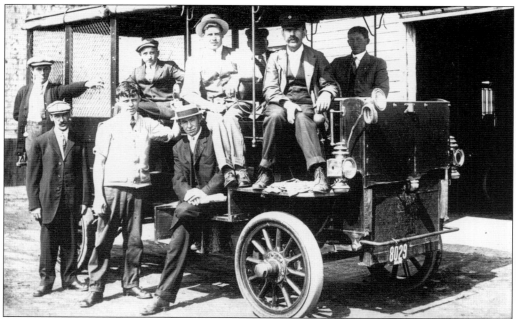

Identified as a 23-horsepower Rapid Motor, this vehicle was used to transport guests from Scarborough Beach Station to the Willows Hotel at Prouts Neck. In an effort to lure customers, hotels were among the first to capitalize on any cutting-edge technology.

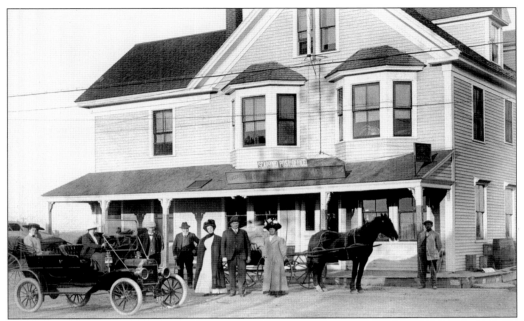

It is unlikely that these people were giving much thought to the transition in transportation captured in this image. The group stands outside Newcomb's store, on Black Point Road, in 1911. Today, the building looks much as it did in this photograph. No longer a store, it is occupied by a small business on the first floor and an apartment upstairs.

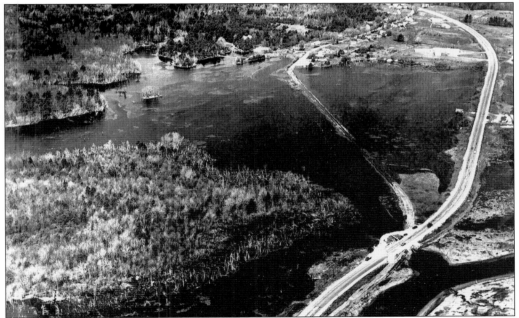

Early settlers traveled on the high ground as much as possible. In this case, the old route was through Dunstan Landing. In the early 1950s, the state undertook a major highway project, building the Pine Point Road across the Scarborough Marsh. Both old and new roadways can be seen in this 1960s photograph.

LINDBERGH DAY
AT PORTLAND
JULY 23rd—NEXT SATURDAY

"PLUCKY" LINDY

"We"—Colonel Charles A. Lindbergh

and the famous "Spirit of St. Louis" will arrive at Scarboro Aviation Field about 1.00 P. M. Will parade through the streets of Portland and about 2.30 P. M. (Standard Time) exercises will be held in his honor at Deering Oaks. If weather is unfavorable, the Exposition Building nearby will be the place. In the evening there will be a banquet at the new Eastland Hotel. "LINDY" will positively not visit any other place in Maine, so take an early train to catch a glimpse of the world-renowned "WE".

RAIN OR SHINE HE WILL BE HERE

RAIL RATES cut right in two for this event of all events

After aviator Charles Lindbergh successfully flew solo across the Atlantic in May 1927, he instantly became a national hero. In the summer of that year, he agreed to tour each state in the *Spirit of St. Louis*. One of his first appearances was in Maine, and Portland was chosen as the city to host America's most popular celebrity. This broadside was produced by the Maine Central Railroad to promote Lindbergh's visit. At the time, the airport for greater Portland was located in Scarborough, and the plan was for Lindbergh to land there and then proceed to Portland by motorcade. The broadside promised passenger rates would be cut in half, as the railroad wanted to capitalize on this event. As it turned out, the weather was so foggy that Lindbergh could not find the airfield and thus flew to Old Orchard and landed on the beach. From there he proceeded to Portland. Some 25,000 people turned out for the event in Deering Oaks Park.

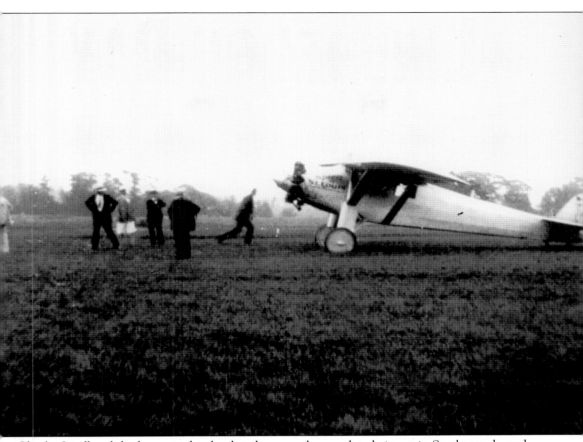

Charles Lindbergh had promised to land at the recently completed airport in Scarborough, and he kept his promise. On Sunday, July 28, he flew the *Spirit of St. Louis* from Old Orchard and landed here. He landed here on many other occasions, but only once in the *Spirit of St. Louis*. (Courtesy of Ira Milliken and Leo Boyle.)

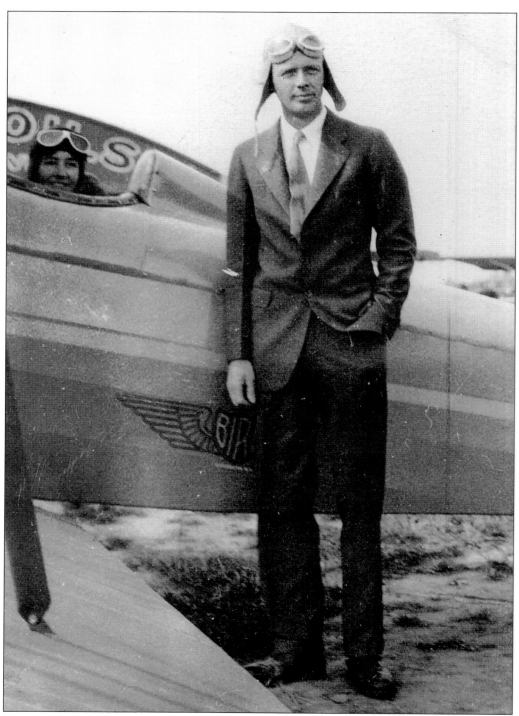

Charles Lindbergh stands beside a Bird biplane at the Scarborough airport. His wife, Ann Morrow, is in the plane. The Lindberghs were regular visitors to Maine, as her family had a home downeast. (Courtesy of Scarborough Historical Society.)

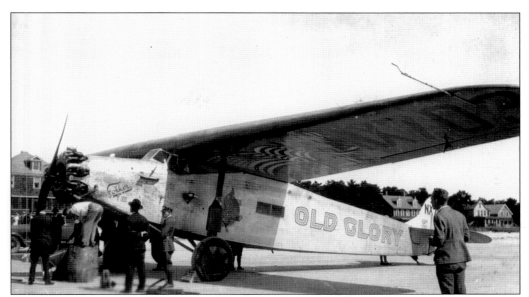

In the mid-1920s, most of the airplanes attempting to cross the Atlantic from this area took off from Old Orchard Beach. One exception was the *Old Glory*, which took off from the Pine Point end of the beach on September 6, 1927. Final preparations are made to the Fokker FVII (above). A crew of three manned the plane. A motorcycle escort led the way on takeoff to clear the beach (below). The mission was ill fated, as the plane was lost at sea. (Courtesy of Leo Boyle.)

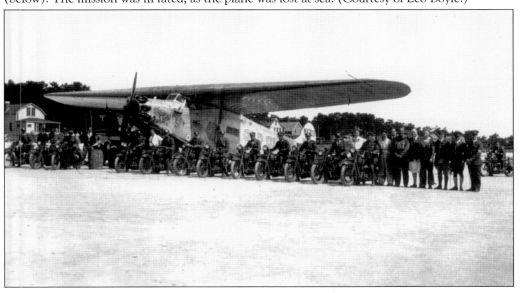

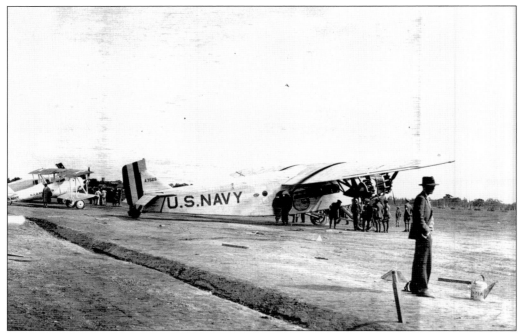

To celebrate the grand opening of the Portland Airport in Scarborough, an airshow was scheduled for September 28–30, 1928. For this event, 45 planes flew in and thousands of people turned out. People inspect a Navy Ford trimotor (above). The Curtiss Hawk belonged to the U.S. Marines (below). (Courtesy of Jack Glatter.)

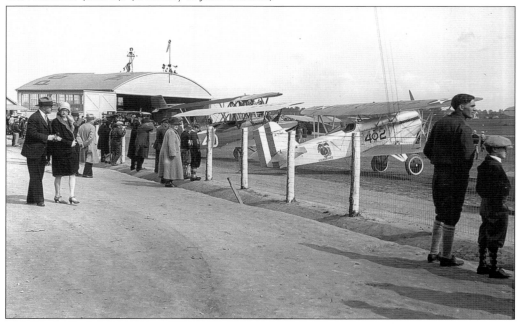

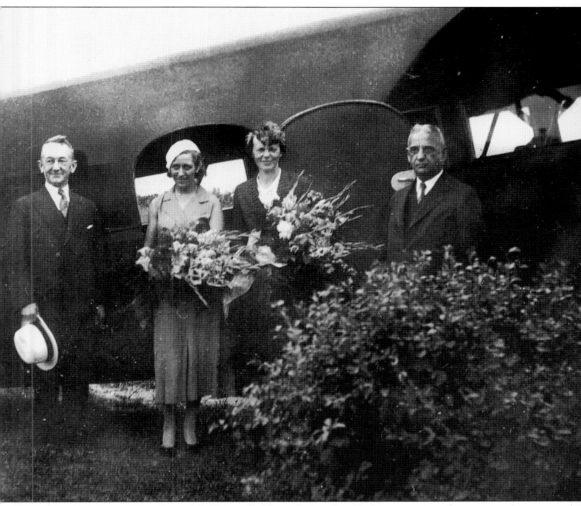

Famous women aviators Amy Mollison (left) and Amelia Earhart receive flowers at the Scarborough Airport in August 1933. Mollison, from England, flew the Atlantic from there, crash-landing in Connecticut. Earhart was known as America's flying queen. The two men are unidentified. (Courtesy of Scarborough Historical Society.)

PORTLAND FLYING SERVICE

INCORPORATED

TRAVEL BY AIR

New Schedule of Low Prices from Portland

TO

DESTINATION	AVERAGE TIME	PRICE
Augusta	35 Mins.	$ 29.00
Waterville	45 "	33.00
Bethel	35 "	29.00
Rockland	45 "	33.00
Farmington	45 "	33.00
Bangor	1 Hr. 10 Min.	49.00
Jackman	1 " 35 "	69.00
Greenville	1 " 30 "	65.00
Calais	1 " 50 "	93.00
Houlton	2 Hrs. 15 Min.	105.00
Caribou	2 " 35 "	120.00
Boston	50 Min.	35.00
Montreal	2 Hrs. 10 Min.	99.00
Quebec	2 " 20 "	107.00
New York	3 " 5 "	125.00

Prices subject to change without notice

Price Includes Round Trip, 1 to 3 Persons, with Reasonable Stopover

COMFORTABLE CABIN PLANES

Flying Instruction Aerial Photography
Government Approved Repair Station No. 151

Connections Made With Any Scheduled Line
Anywhere - Anytime

Portland Airport, Scarboro Tel. Scarboro 118

A broadside for the Portland Flying Service advertises passenger rates for the Portland Airport in Scarborough. (Courtesy Janice Johnson.)

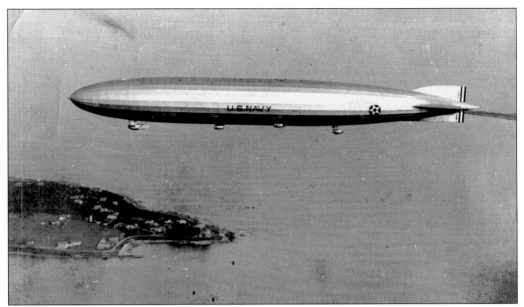

The U.S. Navy airship *Shenandoah* soars high above Prouts Neck on July 3, 1925. The navy used airships as a publicity tool. As history proved, most of the airships met a violent end, and so it was with the *Shenandoah*. It broke up in a clash of wind currents over Ohio on September 2 of the same year. A total of 14 of the 43 crew members were killed.

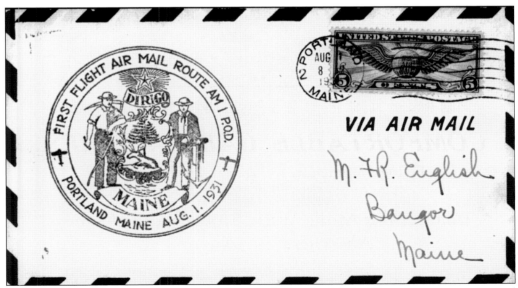

This first-day cover commemorates the first regularly scheduled airline passenger service and the first regularly scheduled airmail in Maine. The flight was from Scarborough to Augusta. The service was short-lived, however. It was canceled after six weeks and not reinstated until 1933.

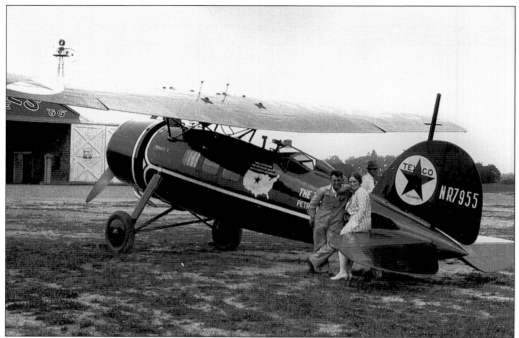

On July 30, 1929, aviator Frank Hawks and an unidentified woman stand near the tail of a Lockheed Air Express at the airport. Hawks was making arrangements for the Ford Reliability National Air Tour. For that October 7, 1929, event, some 25 to 30 airplanes came to Scarborough. (Courtesy of Ira Milliken and Leo Boyle.)

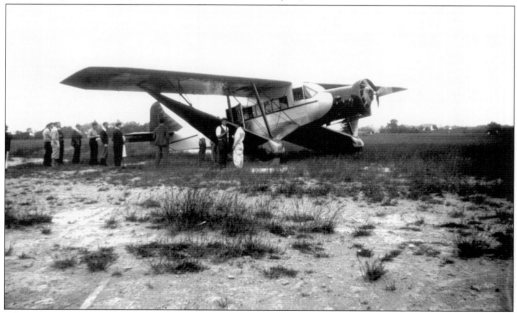

Thousands of Americans flew in an airplane for the first time in the decade of the 1920s. Passengers paid $2 to $5 to take a short, scenic flight. This plane was a Bellanca Air Cruiser owned by Curtis Flying Service. (Courtesy of Eva Storey.)

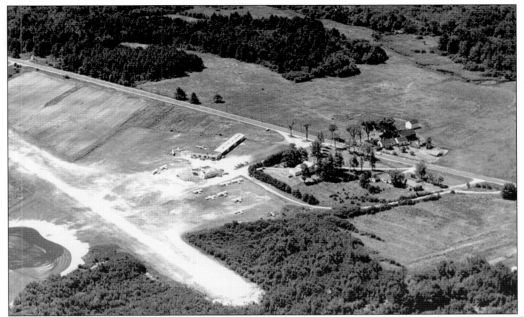

The Port of Maine Airport was a privately owned airfield, located on Pleasant Hill Road near Route 1. Harold Troxel, owner of Portland Flying Service, started the airport after World War II. It was a small airfield at which private planes could be stored, repaired, or chartered. Albert Coppola, owner of New England Aerial Spraying, used this as his base of operation. The airport was sold, and the property was developed in the early 1960s. Commercial Paving occupies much of the site today.

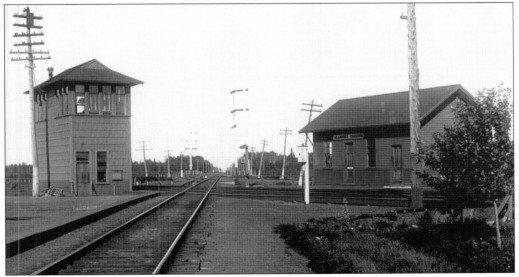

For many years, Scarborough had two rail lines running through town. The tracks intersected near the town line with South Portland. Tower One (left) was the first of three control towers that directed freight destined for Commercial Street in Portland. The passenger trains took the other line to Union Station, also in Portland. Tower One was later moved to Pond View Drive and used as an outbuilding. (Courtesy of Scarborough Historical Society.)

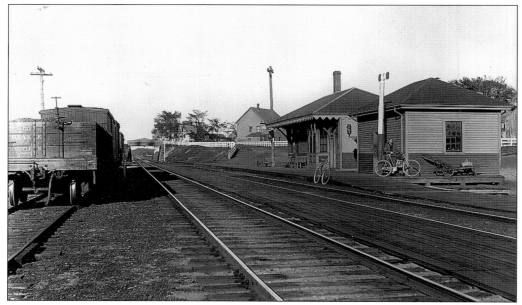

It was a quiet day when this photograph was taken at Scarborough Beach Station, just off Black Point Road. In view are the Oak Hill Grange (background) and a building (next to the station) that was used to store baggage. This station burned in 1908. Its replacement was built on the same site. (Courtesy of Scarborough Historical Society.)

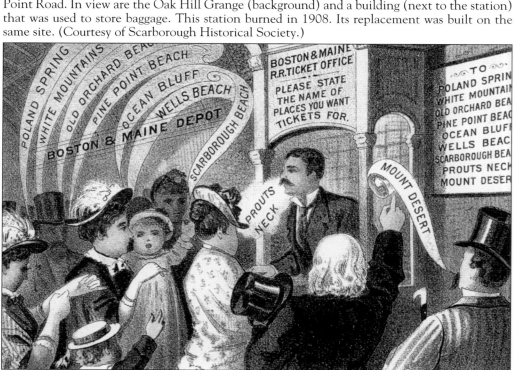

In an effort to increase the number of rail passengers, the Boston & Maine Railroad promoted tourism. Advertising was done in many forms, including this trade card, which features people calling out popular destinations such as Pine Point, Scarborough Beach, and Prouts Neck. At its zenith, the Boston & Maine maintained both sets of tracks through Scarborough.

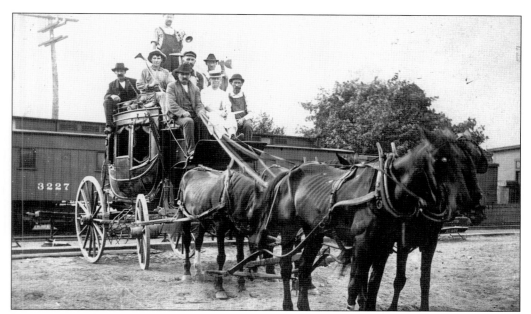

Harris Seavey (at the reins) is the only person identified in what was probably a Labor Day celebration some 100 years ago. He used this Concord coach as a taxi between Scarborough Beach Station and the hotels at Prouts Neck. These local merrymakers all have different tools: a chef's knife, a bugle, a broadax, and a hoe. Labor Day, established in the 1880s, became a federal holiday in 1909.

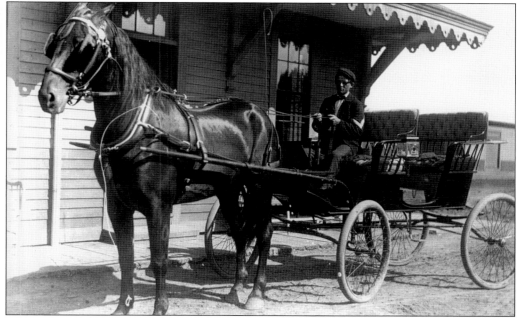

The Pride Livery Stable of Westbrook established a seasonal outlet at the Atlantic House each summer. There was stiff competition for the trips between the train station and the hotels of Prouts Neck. Each driver tried in some unique way to attract prospective passengers. This carriage was fitted with special tires that supposedly gave a comfortable ride.

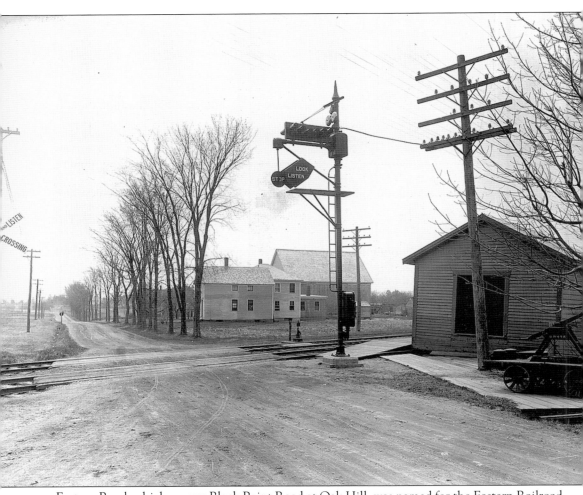

Eastern Road, which crosses Black Point Road at Oak Hill, was named for the Eastern Railroad. In time, the Boston & Maine took over Eastern and this became known as the Eastern Division of the Boston & Maine. The tracks were removed in the 1940s. The Charles O. Libby Homestead still stands and appears much the same today as it does in this 1920s photograph.

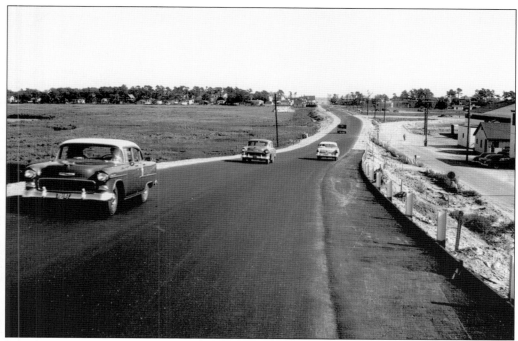

In the early 1950s, the Maine Department of Transportation decided to build railroad overpasses at Pleasant Hill and Pine Point. Passenger train travel was in decline by the time these improvement projects were undertaken in 1954. Cars travel north from Pine Point to Blue Point over the new overpass in 1955 (above). A diesel locomotive passes safely underneath (below). At the height of passenger train travel, as many as a dozen trains a day crossed these intersections. Over the years, many accidents occurred at both locations. (Courtesy of Maine Department of Transportation.)

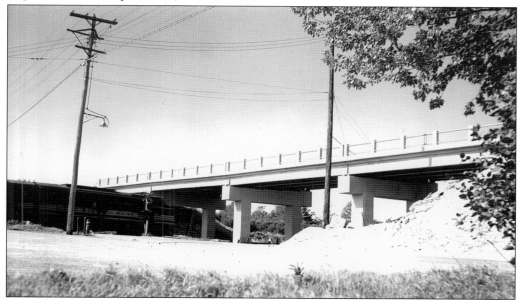

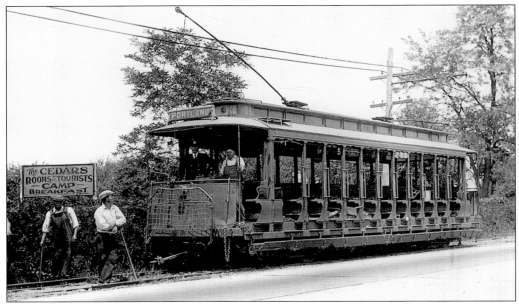

When the Portland Railroad Company established trolley service through Scarborough in 1902, it opened a door of opportunity for the town's business community. The Route 1 corridor was suddenly accessible to thousands of greater Portland residents on a regularly scheduled basis. Open cars, like the one photographed near Oak Hill, were popular in the summer months (above). Shore-dinner houses specializing in lobster dinners were established all along Route 1. The Moulton House in Dunstan was among the most popular. Members of the Portland Medical Club are photographed on the front steps (below). The popularity of the automobile spelled the demise of the trolley line, resulting in its removal in the early 1930s. (Above, courtesy of Frank Hodgdon.)

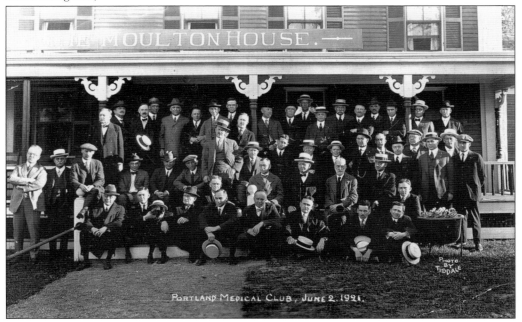

Four

THE TRICENTENNIAL CELEBRATION OF 1958

In July 1958, the town held a celebration in honor of the 300th anniversary of its incorporation. The 10-day event was undoubtedly the best-planned and most extensive celebration in town history. Gov. Edmund Muskie and the mayor of Scarborough, England, pose for a photograph on the beach at Pine Point on July 4, 1958. The mayor and his wife (adjusting Muskie's lobster bib) were guests of the town for the celebration. Muskie went on to become a U.S. senator, a presidential candidate, and U.S. secretary of state.

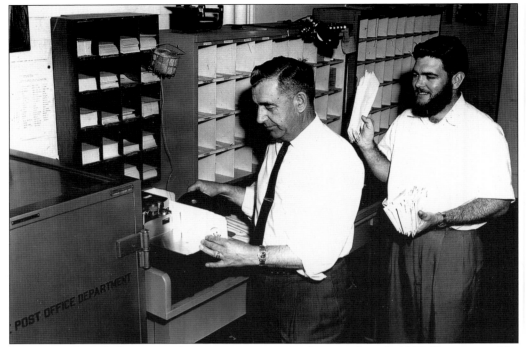

Postmaster Fred Skillings cancels commemorative envelopes on June 2, 1958. He is assisted by postal worker Frank Hodgdon. Known as first-day covers, the envelopes are commonly produced for special events and are a collector's item. It was at this time that Scarborough adopted the blockhouse as its official symbol. (Above, courtesy of Frank Hodgdon.)

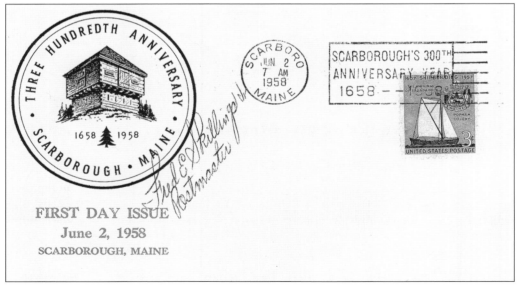

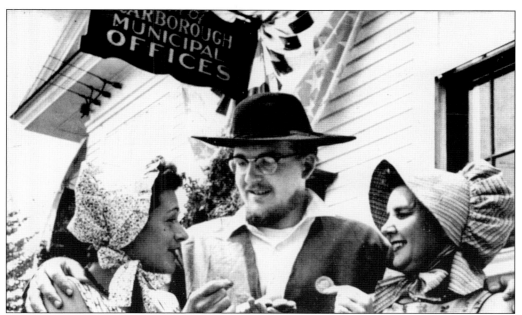

A 50¢ token was produced for the anniversary celebration. The tokens, gold in color, could be redeemed at participating businesses in town. Examining the coins outside town hall are, from left to right, town employees Isabelle Clark, Earl Stevens, and Margaret Hall. Many aspects of the celebration followed a Colonial theme. In bonnets and powdered wigs are, from left to right, Sandra Stanford, Ruth Libby, Louise Morse, Laureen Libby, and Sheila Austin.

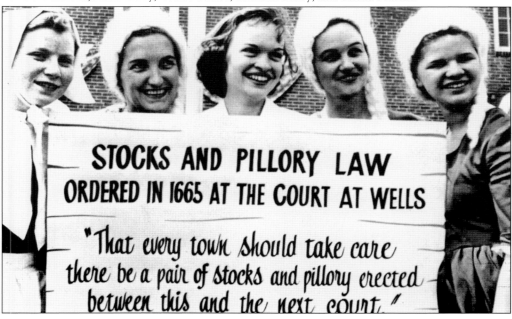

STOCKS AND PILLORY LAW
ORDERED IN 1665 AT THE COURT AT WELLS

"That every town should take care there be a pair of stocks and pillory erected between this and the next court."

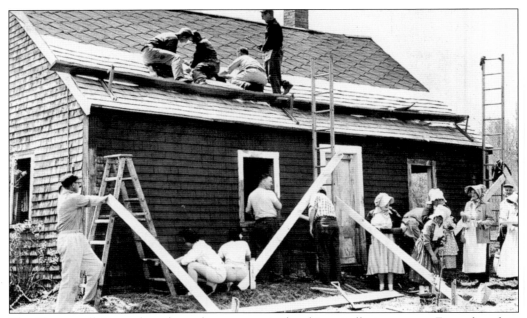

The Hunnewell House has always been recognized as historically important. Even though it was privately owned at the time, volunteers did some much needed repairs in preparation for the celebration.

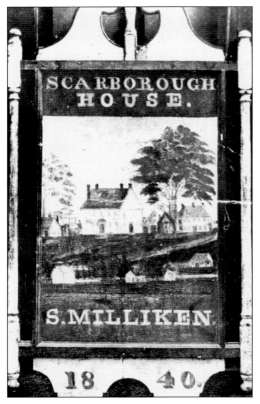

A line of official souvenirs, including a series of postcards, was produced for the celebration. This postcard featured an early sign for one of Scarborough's taverns. The location of this sign today is unknown.

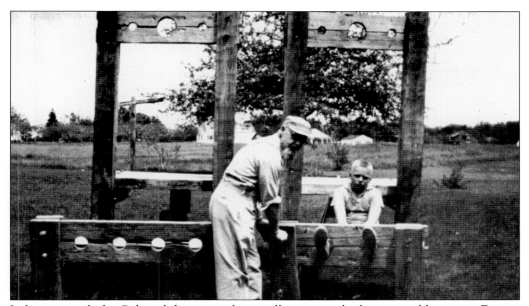

In keeping with the Colonial theme, stocks, or pillories, were built in several locations. Everett Kimball has Neil Paulson captive (above). Nelson Record of Pine Point is receiving the punishment (below). Others in period costume are, from left to right, Rod Ouellette, Joe Brim, Bert Ouellette, Joe Paul, and Conrad Chase. (Below, courtesy of Mary Louise Record.)

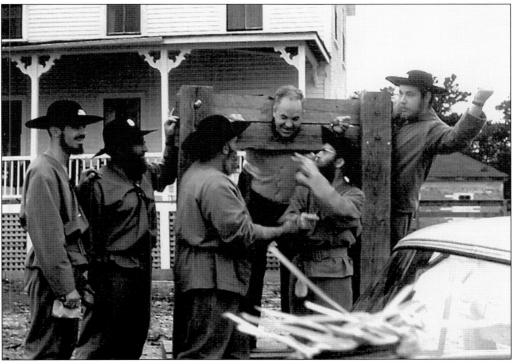

Calling themselves "the Brothers of the Brush," some Scarborough men entered a beard-raising contest. From left to right are the following: (front) Ken Dolloff, Joe Paul, Cliff Leary, and Paul Webster; (middle) Alan Durgin; (back) Joe Brim, Frank Hodgdon, Frank Melcher, Horace Davenport, Bert Ouellette, Earle Stevens, Warren Delaware, and Stan Ricker. (Courtesy of Frank Hodgdon.)

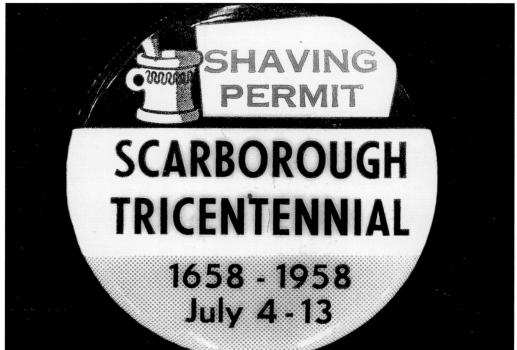

Men who did not wish to participate in the beard-raising contest were required to purchase a shaving permit. A clean-shaven man had to display this badge or he could be placed in the stocks. This was some of the good-natured fun that was part of the festivities.

Five

SCHOOL DAYS

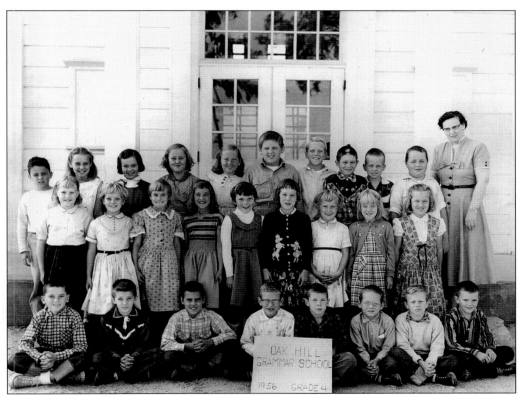

The students in this fourth-grade class at Oak Hill Grammar School went on to graduate in the class of 1965. From left to right are the following: (front) Philip Hunt, Kenny Jackson, Michael White, Ben Coulthard, Paul Cressey, Wayne Purington, Roy Simmons, and William Morse; (middle) Ann Legacy, Mary Ann Barday, Robert Chase, Nancy Crowley, Priscilla Nowell, Louise Snow, Glenda Clifford, Kathy Hodgdon, and Joanne Nelsen; (back) Dan Broy, Linda Clark, Bette Libby, Lynn Davidson, Kathleen Friel, Ed Wheeler, Charlie Webber, Raymond Pelletier, Jim Kenoyer, Bobby Lyons, and teacher Doris Downing. (Courtesy of Ilene Adams.)

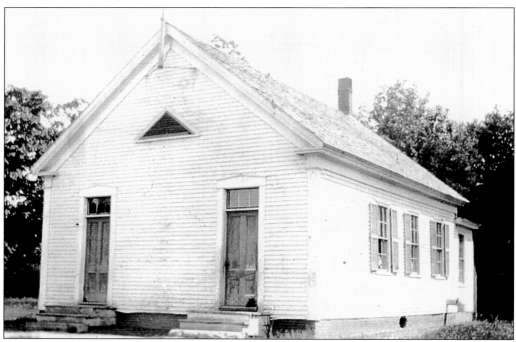

Now used for community functions, the one-room Beech Ridge School still looks much as it did in the days when classes were held here. Students posing in 1915 are, from left to right, as follows: (front) Annie Berry, Doris Mitchell, Ruth Sherwood, Abbie Scott, Hazel Berry, Martha Pillsbury, Hazel Merry, Lena Scott, George Merry, Arthur Pillsbury, Ross Sherwood, and Mertrude Emerson; (middle) Ida Berry, Marcia Merry, Alice Patnaude, Rena Scott, teacher Mabel Storey, Mildred Sherwood, Raymond Emerson, L. Storey, Edgar Milliken, Bill Temm, Frank Mitchell, and Irving Berry; (back) Emily Temm, Rachael Scott, Ruth Bragdon, Laurence Merry, and "Porky Jones, the mill worker's boy." Note the number of children in bare feet. (Courtesy of Faye Holmes.)

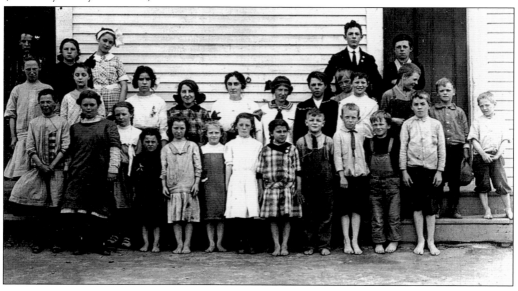

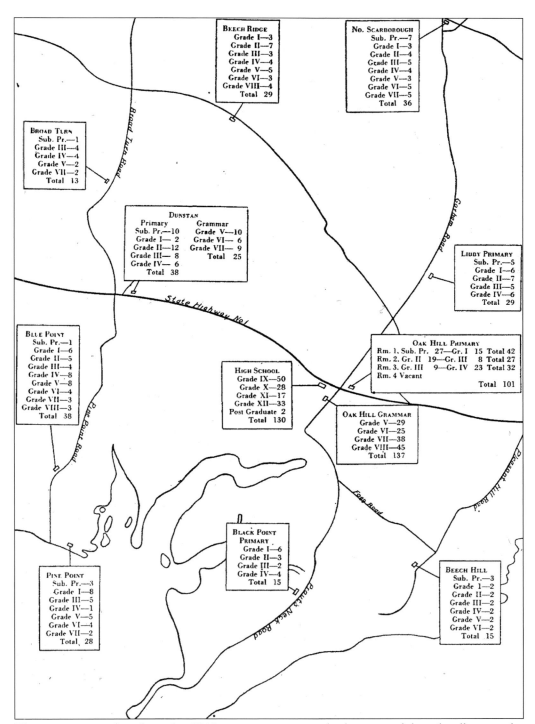

BEECH RIDGE
Grade I—3
Grade II—7
Grade III—3
Grade IV—4
Grade V—5
Grade VI—3
Grade VIII—4
Total 29

No. SCARBOROUGH
Sub. Pr.—7
Grade I—3
Grade II—4
Grade III—5
Grade IV—4
Grade V—3
Grade VI—5
Grade VII—5
Total 36

BROAD TURN
Sub. Pr.—1
Grade III—4
Grade IV—4
Grade V—2
Grade VII—2
Total 13

Broad Turn Road

DUNSTAN

Primary	Grammar
Sub. Pr.—10	Grade V—10
Grade I— 2	Grade VI— 6
Grade II—12	Grade VII— 9
Grade III— 8	Total 25
Grade IV— 6	
Total 38	

Gorham Road

LIBBY PRIMARY
Sub. Pr.—5
Grade I—6
Grade II—7
Grade III—5
Grade IV—6
Total 29

State Highway No 1

BLUE POINT
Sub. Pr.—1
Grade I—6
Grade II—5
Grade III—4
Grade IV—8
Grade V—8
Grade VI—4
Grade VII—3
Grade VIII—3
Total 38

HIGH SCHOOL
Grade IX—50
Grade X—28
Grade XI—17
Grade XII—33
Post Graduate 2
Total 130

OAK HILL PRIMARY
Rm. 1. Sub. Pr. 27—Gr. I 15 Total 42
Rm. 2. Gr. II 19—Gr. III 8 Total 27
Rm. 3. Gr. III 9—Gr. IV 23 Total 32
Rm. 4 Vacant
Total 101

OAK HILL GRAMMAR
Grade V—29
Grade VI—25
Grade VII—38
Grade VIII—45
Total 137

Pine Point Road

Foss Road

Pleasant Hill Road

BLACK POINT PRIMARY
Grade I—6
Grade II—3
Grade III—2
Grade IV—4
Total 15

Prouts Neck Road

PINE POINT
Sub. Pr.—3
Grade I—8
Grade III—5
Grade IV—1
Grade V—5
Grade VI—4
Grade VII—2
Total 28

BEECH HILL
Sub. Pr.—3
Grade I—2
Grade II—2
Grade III—2
Grade IV—2
Grade V—2
Grade VI—2
Total 15

This town map, taken from the 1940 town report, gives the location of the schoolhouses, the grades, and the number of pupils. Many were still one-room schools. In the following decades, the town began the process of consolidating the schools into centrally located larger schools.

Tax Payers of Scarboro Watch Out!

Are you willing to mortgage your homes to help pay for a $75,000 High School building, or will you vote **against** such **extravagance**?

The Town Reports show that in 1913 the tax rate was $13.40, in 1925, $36.00. **WHAT** will it be in **1926** if the town borrows **$75,000** to build a new High School building which is only the beginning of the expense? Remember interest on the $75,000 must be added to the loan, which, for a term of years, is no small sum. Reckon it and see!

Remember too that $74,278 for town expenditures was raised at the last annual meeting, making a total of $149,278 to be assessed for.

THINK of the maintenance of such a building.

Why not enlarge and remodel the present High School building?

Provision for this were made by the contractor at the time it was built should it be necessary to do so at any future time.

This can be done at a reasonable cost, keeping our taxes within our pocket-books.

If you allow this unreasonable proposition to stand, you will have to pay unreasonable taxes because taxes are assessed on the amount of money raised.

The Town Reports show there were 61 pupils registered in the High School in the fall of 1922; in the fall of 1925, 62 pupils—an increase of **one** pupil in **three** years.

Is this **registration** and **increase** sufficient to require a $75,000 building?

Think these facts over, taxpayers, and present yourselves at the polls on Saturday, April 3rd, at 2 p. m., to protect the welfare of your families and town.

Political differences are an important part of the democratic process. Proposed school projects are almost always the topic of heated debate. In this handout objecting to the construction of the Bessey School, the project's price tag of $75,000 is cited as an extravagance. Nevertheless, the school was built. It served the town well for many years. (Courtesy of Scarborough Historical Society.)

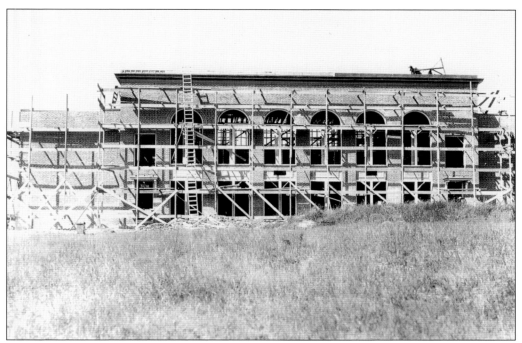

In the mid-1920s, the ever growing population in Scarborough created the need for a new high school. The school is shown under construction in 1926 (above), and after completion in 1927 (below). It became known simply as Scarborough High School until 1954, when it was renamed for beloved principal and teacher Elwood G. Bessey, who had retired six years previously. No longer used for classes, the building is still owned by the town.

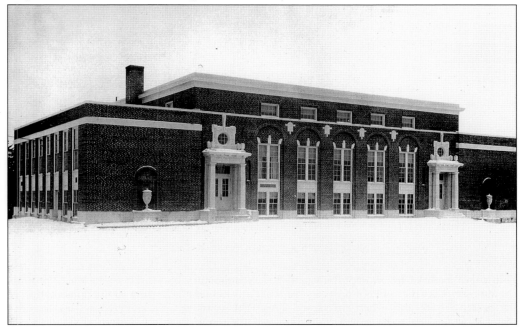

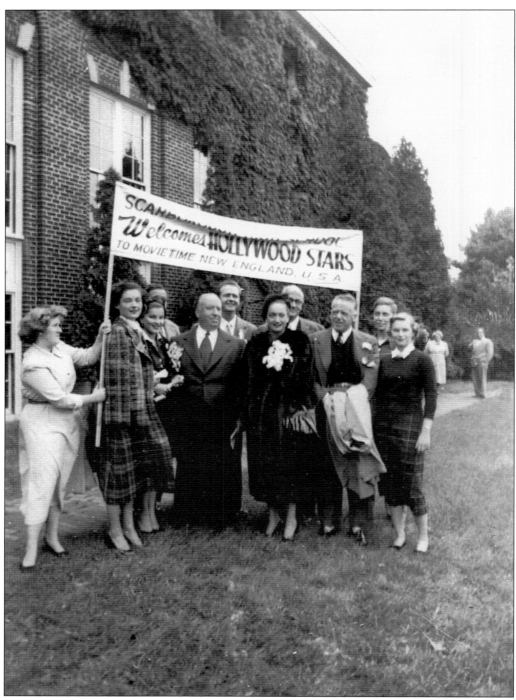

"It was very exciting." This was how one student recalled the 1952 visit to Scarborough of Alfred Hitchcock and other Hollywood stars. The visitors, who included actress Dorothy Lamour, were on a promotional tour. This was their only Maine appearance. (Courtesy of Trudy Sherwood.)

FOUR

CORNERS

OTHO BAKER
SENIOR NUMBER,
JUNE, 1915

Scarborough High School published its first yearbook in 1912. It was called *Four Corners* for the proximity of the school to the Oak Hill intersection. The books have been published every year since 1912 with the exception of 1933, when at the height of the Depression, not enough advertising could be sold to pay for the publication. The 1934 book included a senior section for 1933. The books are not only keepsake mementos but also valuable records of the students, faculty, sports teams, and clubs.

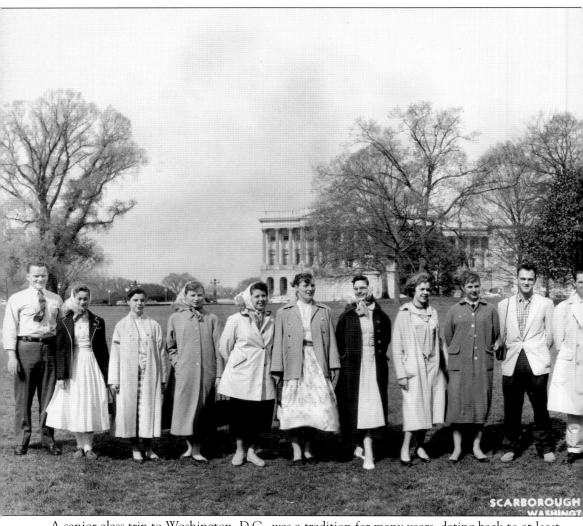

SCARBOROUGH
WASHINGT

A senior class trip to Washington, D.C., was a tradition for many years, dating back to at least 1915. This spring trip was made by bus, and the group was from the class of 1958. From left to right are the bus driver, unidentified, Joan Frederick, Nancy Lothrop, Sandra Stanford, Dorothy Labbe, Beverly Nichols, Beverly Stevenson, Sally Foster, Judy Harmon, Dale Sinclair, Dale

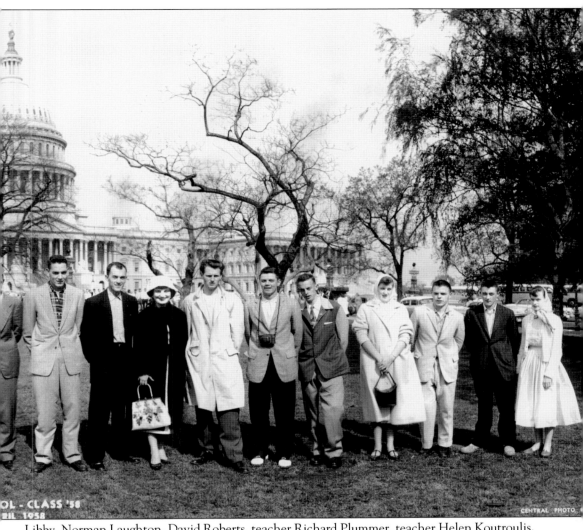

Libby, Norman Laughton, David Roberts, teacher Richard Plummer, teacher Helen Koutroulis, Gerald Applebee, Charles Hill, William Coulthard III, Marilyn Moulton, William Marles Jr., George Bennett, and Louise Morse. (Courtesy of Norman Laughton.)

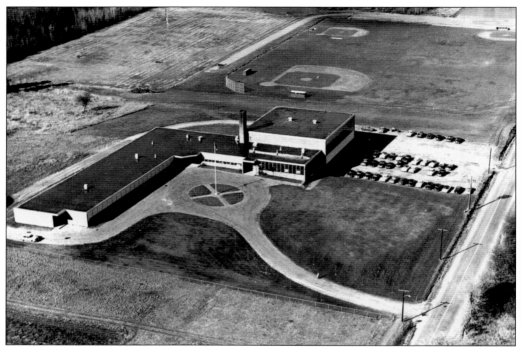

Scarborough High School moved to its current location in 1954. The town administration at that time did an excellent job in selecting the site, which has allowed for several additions necessitated by the ever increasing student population. This aerial view was taken c. 1958.

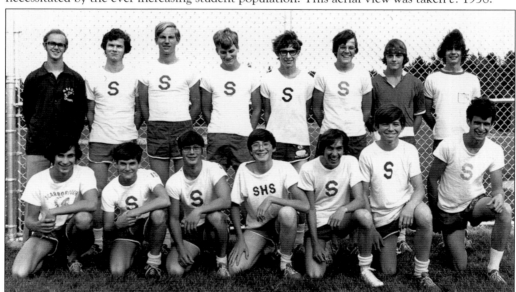

In only his second year of coaching, Ron Kelly led this team to the Southwestern Maine Class C cross-country championship in 1973. Rick Libby, a freshman, was the lead runner. From left to right are the following: (front) Jeff Verrill, Steve Kelly, Jeff O'Donnell, Mark Allen, Kevin Gile, Rodney Laughton, and Bill Moulton; (back) Kelly, Dave Packhem, Dave Leavitt, Greg Kelly, Libby, Mike Rutherford, Mark Tocher, and Scott McMichael.

In 1940, Scarborough High School adopted the name Redskins for the varsity basketball team to differentiate it from the freshmen team, the Arrows. In time, the Redskins name was used by all Scarborough sports teams. It was synonymous with the virtues of bravery, stamina, and skill. The name was dropped in the late 1990s in a campaign to clear ethnic reference from school affiliation. Robert Scammon (left) and Joe Tufts hand-painted the likeness of an Indian chief on the gymnasium wall at Scarborough High School in October 1989. The mural has been preserved because of its artistic integrity. (Courtesy of Joe Tufts.)

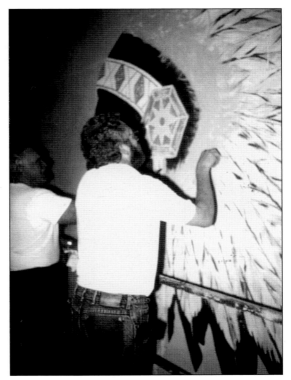

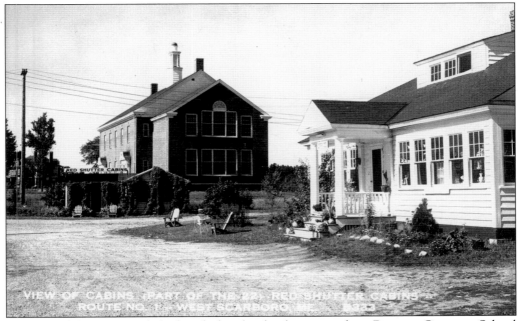

Scarborough has constantly had to deal with school overcrowding. Dunstan Grammar School (foreground) was built to replace a one-room schoolhouse located nearby. When this two-room structure became overcrowded, the town built the brick school (also shown). Ultimately, the school was outgrown and sold by the town. It is now Dunstan School Restaurant.

PROGRAM

Oak Hill
Parent - Teacher
Association

1946 - 1947

SCARBOROUGH, MAINE

The Scarborough Parent-Teacher Association (PTA) was organized on February 25, 1946. The first meeting was held at the high school. Those involved with the organizing were Frances Libbey, Mary Skillings, Eleanor Atwood, Katherine Brown, Edmund Ritchie, and Hope Mitchell. Like PTA groups anywhere, it dealt with issues of school nutrition, safety, and book content, among other things.

Six

HOMESTEADS

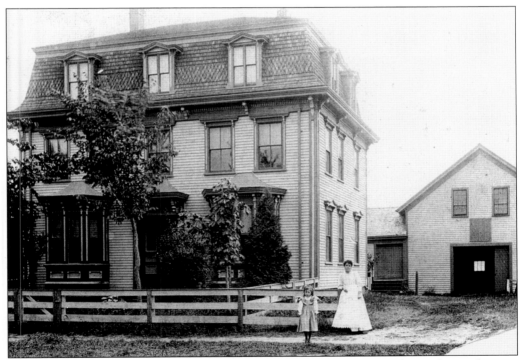

The Mark Milliken residence, in Dunstan Village, is more reminiscent of a city house than are the other homes in the neighborhood. It is located on Route 1 between the Pine Point and Old Blue Point Roads. This house was used as a funeral home during the latter part of the 20th century and was then occupied by a dance studio. (Courtesy of Joellen Knight.)

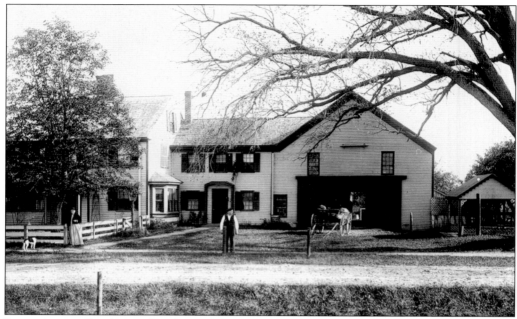

Route 1 was still a dirt road in front of this Dunstan Village homestead. In Colonial times, the homestead was operated as a tavern and owned by the Millikens. Throughout most of the 20th century, it was home to Myron and Bertha Moulton. After that, it was used as a restaurant. Today, with a large addition, it is part of Dunstan Ace Hardware. (Courtesy of Everett Withee and Jim Leary.)

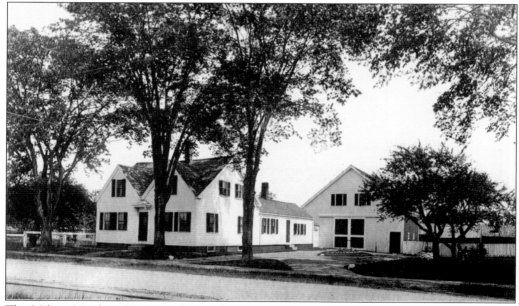

The Milton Moulton Homestead next-door was typical of the gracious homes that once lined Route 1 in Scarborough. As automobile travel increased, the roadway was widened, with pavement reaching almost to the front steps many of the homes. These buildings are gone, and the site is now the parking lot for Ace Hardware.

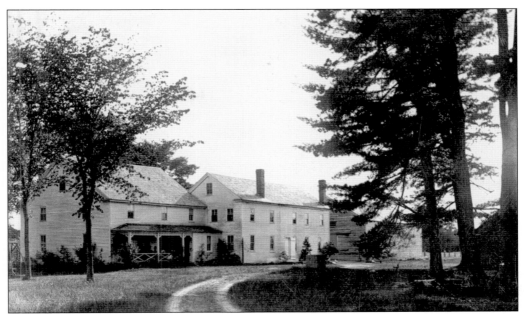

Originally the Larrabee Homestead, this North Scarborough house had a fireplace large enough to stand up in. A century ago, the women put on oyster stew suppers and weekend dances to provide income. The property became noted for the large white pines that grew there. The buildings are now gone, and the Ottawa Woods neighborhood is located on the site.

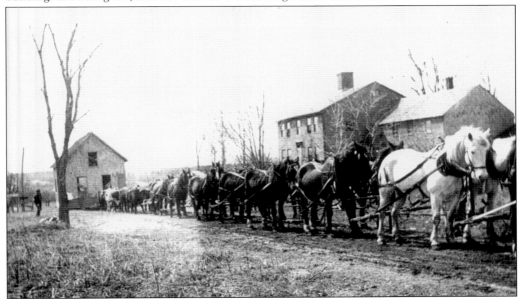

Before electric wires crossed roadways, it was fairly easy to move homes and outbuildings from one location to another. The work was usually performed in the winter months, when snow-packed roadways made it easy to drag buildings. In this 1916 view, horses and oxen are moving a house from Scarborough to Westbrook. The large homestead in the background belonged to the Sherwood family. It still stands at the corner of Holmes and Beech Ridge Roads. (Courtesy of Faye Holmes.)

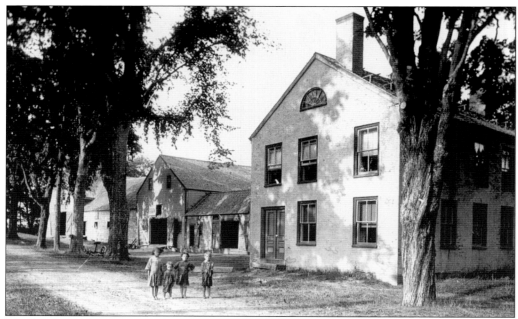

This brick farmhouse was built on Beech Ridge Road in the mid-1700s. On the stagecoach line to the interior, it was used as a tavern and inn. For many years, it was the Merry Homestead. Pictured in this c. 1915 view are Marcia, Muriel, Hazel, and George Merry. The homestead is still a working farm. The fields are used to commercially raise Christmas trees and are also open for cross-country skiing. (Courtesy of Faye Holmes.)

The Dr. Benjamin Wentworth Homestead was located at Oak Hill. The land now occupied by the high, intermediate, and middle schools was once part of this property. The house was torn down shortly after this picture was taken in the early 1960s. Oscar G's Ice Cream and Grondin's Exxon Station now occupy the site. The elm tree still stands as an Oak Hill landmark. (Courtesy of Larry Jensen.)

Scarborough has always done a good job of recycling its old school buildings once they have been outgrown. At Oak Hill in 1906, Walter Sparrow purchased this schoolhouse for $65 (above). He paid an additional $45 to have it moved across the roadway. A carpenter and sign painter by trade, he added a front porch, decorated with beach stones, and called the place Greystone. Mrs. Sparrow took in tourists to supplement the family income. In the vintage postcard view (below), the house looks much the same as it does today. It is located next to Arlberg Ski Shop, which was originally the schoolhouse built by the town to replace the one the Sparrows bought. (Above, courtesy of Mary Sparrow.)

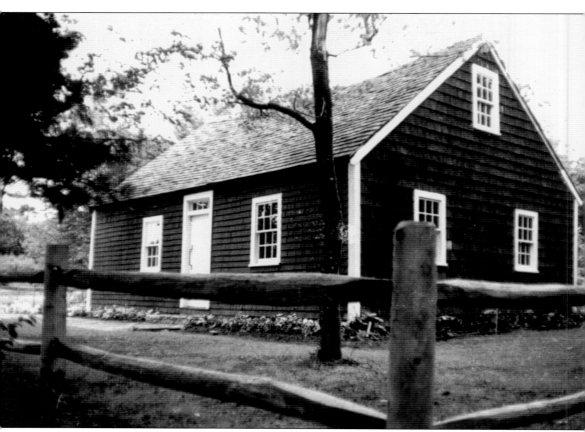

The Hunnewell House is known as the oldest house in Scarborough. In fact, it is the oldest house in Cumberland County. Conflicting accounts exist as to its exact history. It was occupied by Richard Hunnewell, the fabled Indian fighter of the Colonial period. The exact year of construction is in doubt. However, some accounts list it as 1673. The building has been moved several times. It is believed to have once been on Plummer's Island beyond Winnock's Neck. It was moved to the area near the intersection of Highland Avenue and Black Point Road. It was again moved to a location across the street from where it now stands. In the 1750s, Hunnewell's grandson Roger ran a store in the house. Having lost an arm in the battle of Louisburg in 1745, he returned to Scarborough and became a storekeeper because of his physical limitations. In later years, the house was privately owned and occupied as a residence until the 1940s. It was renovated for the town's tricentennial celebration in 1958, but by the early 1970s, was in a state of total disrepair. In 1976, James Nye donated the house and a parcel of land to the town, and the house was moved and renovated again for the U.S. bicentennial. The house and grounds have been well maintained since that time.

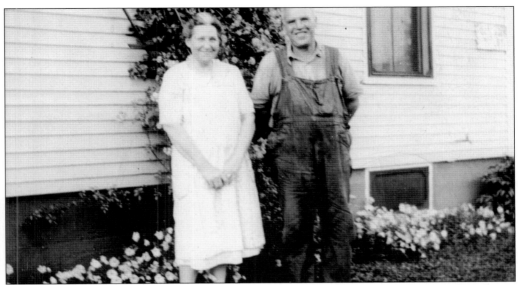

The Richardson family was the first to establish a year-round home after Higgins Beach was subdivided in 1897. Sadie and Lorin Richardson (above) were married in 1901 and always made their home on Greenwood Avenue near Pearl Street. Richardson worked for the railroad and acted as constable at the beach during the summer months, when the population increased dramatically. Sadie Richardson conducted a real estate business from home. The Richardsons also accommodated summer tourists. They moved an old schoolhouse from Pleasant Hill to a vacant lot next door and remodeled it into a rental cottage they called School Days. The Richardson house is on the left, and School Days is in the center (below).

This Libby Homestead was a saltwater farm that ran from Black Point Road to the ocean near Kirkwood Road. It was the home of Charles E. and Sarah Libby and their three children, Clifford, Lena, and Lucien. In later years, like other farm families, Libby and his wife lived on the first floor and son Clifford and his wife, Ethelyn, lived upstairs. The son was a market gardener, and his wife was secretary for the Prouts Neck Association for many years. After she retired, the couple started a seasonal cabin-rental business in the late 1930s. The cabins were located along the oceanfront section of the farm. The tip of Scarborough Beach can be seen (below). The Ginn family eventually bought the property and built a home overlooking the ocean. Today, the farm buildings and cabins are gone, and the property is largely undeveloped.

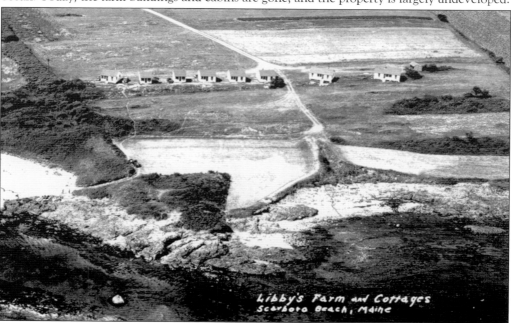

Libby's Farm and Cottages
Scarboro Beach, Maine

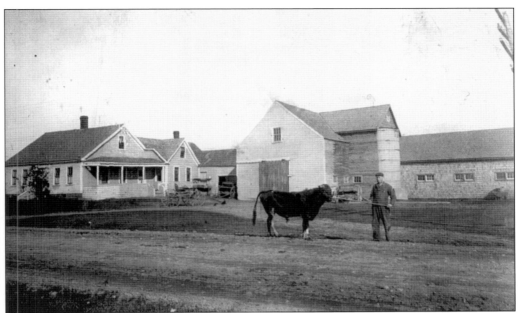

The Harmon Homestead was a classic early Cape-style home with attached outbuildings (above). It stood at 238 Black Point Road. Frank Harmon can be seen holding a bull by a staff. The staff had a hook that held the bull by the ring in his nose. The "new" buildings that replaced the old ones are a testament to the adage about the frugal Yankee (below). In the early 1920s, when holes 10 through 18 were added to the Prouts Neck Golf Course, Harmon and his son Elva cut the trees, harvesting enough lumber to build the home. A few years later when a train wreck demolished the railroad overpass on Black Point Road, Elva Harmon salvaged timbers to frame the barn. These buildings are now gone, and a ranch-style home occupies the site. (Courtesy of Delona Cronkite.)

This fine home at Pleasant Hill four corners was the Jordan Larrabee Homestead. Jordan Larrabee (1818–1884) learned the carpenter's and joiner's trade and, after several years in that occupation, built this home and became a farmer. In the 1990s, the farmland was subdivided into the Settlers Green development. The farmhouse and outbuildings appear today much the same as they do in this vintage photograph.

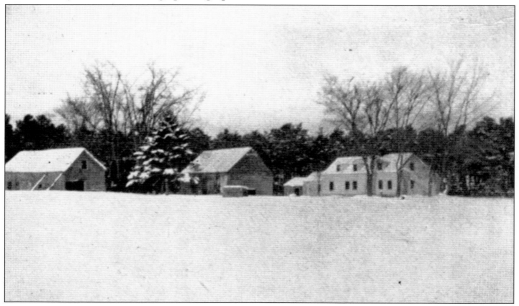

The Wiggins family lived in this homestead at Prouts Neck for generations. When the property came up for sale, a rumor circulated that the trolley line might be extended to that area from Cape Elizabeth. The people of Prouts Neck intervened. They purchased the property and developed it into the first nine holes of their golf course.

Seven

NOTEWORTHY PEOPLE

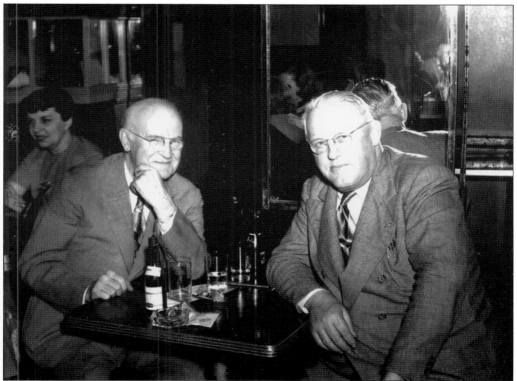

Scarborough citizens have distinguished themselves in many fields around the world. The people, from all walks of life, and their accomplishments make history interesting. In this view, Roy Moulton (left) of Dunstan and Fred Snow of Pine Point enjoy one another's company at the Picadelli Circus Bar at Times Square in New York City. Snow's clam products became nationally known. Moulton was the hotel manager of the Picadelli, one of New York's finest hotels in the 1940s and 1950s. (Courtesy of Harold Snow.)

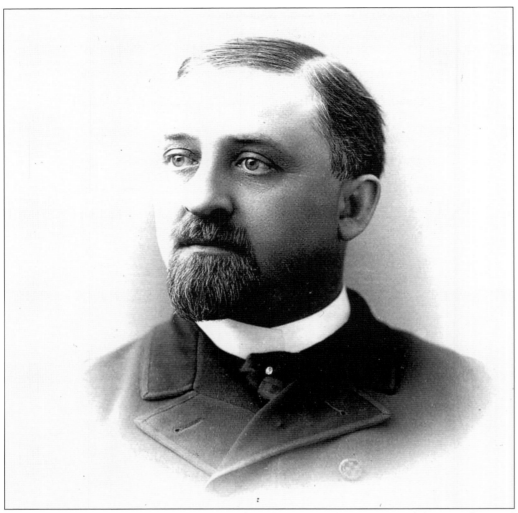

From an early age, Augustus Freedom Moulton (1849–1933) was groomed for a professional life by his father, who was a teacher. He attended the finest preparatory schools and graduated from Bowdoin College in 1873. After studying law in Portland, he was admitted to the bar in 1876. He provided the defense in the 1884 murder trial of Thomas Libby of Prouts Neck. Libby, who had suffered terribly as a prisoner during the Civil War, was ultimately convicted of murdering Lydia Snow of Pine Point, a young woman employed at Libby's hotel. What makes this case interesting is that Moulton used posttraumatic stress syndrome as the basis of Libby's defense. This concept was widely used 100 years later at the time of the Vietnam War. While living in Scarborough, Moulton represented the town for two terms in the state legislature. In time, he moved to Deering and served as the last mayor of that city before it was annexed to Portland in 1899. Throughout his life, he had a strong interest in local and state history. He was the author of several books, the most notable being *Portland by the Sea, Old Prouts Neck*, and *Grandfather Tales of Scarborough*. He became the president of the Maine Historical Society and served on the board of trustees of numerous organizations. In 1927, he was appointed by the governor to the position of state historian, a post he held until his death in 1933 at the age of 84. He never married. Before his death, he gave $200,000 to Bowdoin College to establish the Moulton Union.

Dr. Philip J. Haigis (1916–1994) was born in Foxboro, Massachusetts, the son of a physician. He graduated from Dartmouth College in 1938 and went to medical school in Missouri. In 1940, he married Faith Stone, and the couple came to Scarborough in 1944. They established their home and medical practice on Route 1 at the corner of what was then Scottow Hill Road. In the early years, Haigis was the only physician in Scarborough. He saw patients seven days a week. Office hours included weekend and evening appointments. He made house calls and kept a schedule at the Osteopathic Hospital in Portland. He often responded to serious automobile accidents. Realizing that an ambulance service was needed, he presented this idea to the recently formed Scarborough Lions Club, of which he was a charter member. The club financed and outfitted the first municipal rescue unit in Maine and gave it to the town in 1951. Haigis served as the director and instructor. He was the official town physician and, in that capacity, served the Scarborough schools for a 30-year period beginning in 1945, visiting all the schools and checking each student. He was a promoter of athletics and a driving force to establish the current athletic fields at Scarborough High School. Observing the relief and support efforts extended to firefighters during the 1947 forest fires, he helped establish the Scarborough mobile canteen. He retired in 1975 to Puerto Rico. When Exit 6 of the Maine Turnpike was established, its new access road was appropriately named Haigis Parkway, after a leading citizen of the town.

In each generation, there are teachers who stand above the rest as having a major impact on the lives of those they teach. Many students who went to Scarborough High School between 1930 and 1973 say that Marguerite Lary (1902–1997) possessed the teaching qualities that truly inspired them. She received some of her higher education in New York City and, while there, developed an interest in theater. She shared this with her students throughout her teaching career. She directed countless class plays and coached speaking competitions. Especially in the early years, she exposed the theater to a student population that otherwise would have been oblivious to this form of entertainment. In 1933, she married R. Leon Lary, a poultry farmer who worked for the Maine Turnpike Authority for 21 years and served in many capacities of town government. The couple had three children and made their home in West Scarborough. The square brick house, which still stands, served as a tavern in Colonial times. In her retirement years, Marguerite Lary organized the Scarborough Senior Citizens Club and served as its first president. In 1978, she was named Maine Mother of the Year, a well-deserved award for someone who had given so much to so many. She attended reunions and corresponded with her students. The 1950 photograph was taken while the Larys were chaperones on the senior class trip to Washington, D.C. (Courtesy of Frank Hodgdon.)

Vladimir Krijanovsky (1893–1981) was born in Russia and attended school there, graduating from Nicholas Military Academy. He served in the Russian Revolution and World War I. After serving with the British army in the Near East, he arrived in the United States in 1920 and became a professor of Russian history and culture at the University of Oregon. He came to Scarborough in 1932 and served in the U.S. Army during World War II. He married Marion Weed Krijanovsky, and the couple lived on the Dunstan Landing Road. In 1959, he founded Krijanovsky Insurance Agency. For 36 years, he served as marshal of the Scarborough Memorial Day Parade. A proud American, he appreciated the freedom that most Americans take for granted. A story is told of how he interrupted the proceedings of a meeting after noticing that the American flag in the room was not being properly displayed. The situation was quickly rectified.

Addie Kaler Vaill (1878–1957) was from a well-known and prosperous family. Her father, John Kaler, built the Southgate, a summer hotel now known as Black Point Inn. She devoted her life to family and deeds that benefited the community. She was involved with the public library throughout her life and also served on the committee that erected the Soldiers Monument in Dunstan. She was chosen to unveil the statue before the largest crowd ever assembled in Scarborough. She financed the tomb at Black Point Cemetery in 1936 and established a trust fund to provide perpetual care for the entire cemetery. She made generous contributions to the Black Point Congregational Church. Her greatest legacy was the establishment of Kaler Vaill Home for Women, a retirement home for up to 15 residents that she and her husband, Edward Vaill, a prominent Portland businessman, had envisioned and planned. After her death in 1957, her residence, at 382 Black Point Road, was expanded and Kaler Vaill Memorial Home for Women was opened in 1960. (Courtesy of Kaler Vaill Home.)

Addie Kaler Vaill's maternal grandfather, James Frank Coolbroth (above), built his homestead in 1862. He studied law and is remembered as legal adviser to summer resident and famed artist Winslow Homer. Coolbroth had one child, daughter Elmira Coolbroth, who married John Kaler. Kaler Vaill Home is pictured in 1960 (below), after 12 bedrooms and a large sitting room had been added to the side of the existing home. It appears much the same today. (Above, courtesy of Kaler Vaill Home.)

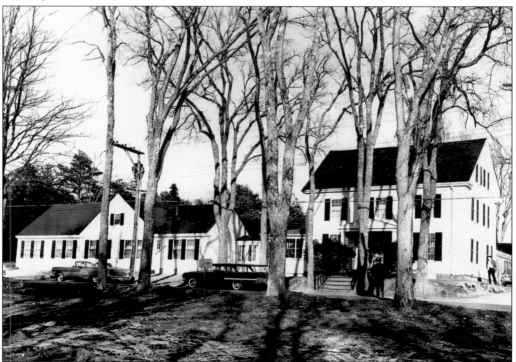

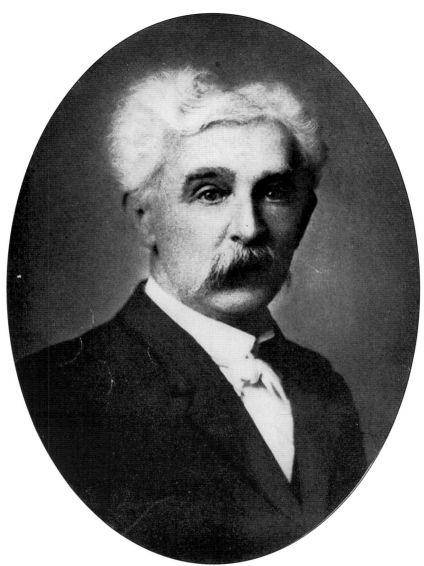

James Otis Kaler (1848–1912) was born in Winterport. His father, Otis Kaler, moved the family to Scarborough, where James received a primary education. The elder Kaler purchased the Kirkwood House, a summer hotel on Scarborough Beach, and wanted his son to follow him in the hotel business. James Kaler, however, had ideas of his own and left home at an early age. His brother John Kaler stayed and carried on the hotel tradition, establishing the Southgate Hotel. At age 17, James Kaler went to work for a newspaper in Boston, beginning his writing career. He eventually moved to New York and wrote *Toby Tyler*, the story of a young boy who ran away with a circus. This, his first book, gained him national popularity. More than 150 other books for young readers followed, the majority of them nonfiction. For most of his career, Kaler wrote under the pen name James Otis. Kaler, an uncle of Addie Kaler Vaill, settled in South Portland and became the first superintendent of schools there. Kaler Street and Kaler School are named in his honor, and a room at the South Portland Public Library is dedicated to his work.

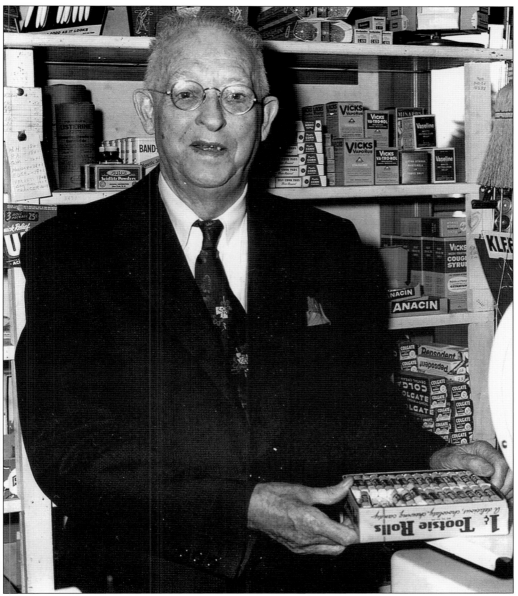

Velorus "V. T." Shaw (1880–1964) came to Scarborough at an early age. He married Etta "Dillie" Libby, a Scarborough native. The Shaws established a store on Black Point Road near Scarborough Beach Station. The store was prosperous from the start, and the Shaws soon established a second seasonal location, at Prouts Neck. In a newspaper interview in 1959, Shaw said that the future of the grocery business was in the hands of chain stores. He turned out to be correct. He continued by saying there was money to be made in selling beer but that was one thing he had never done and did not intend to start. For years, the post office was located in one of his stores. At the time of his death, at the age of 85, he had more than 60 years in the grocery business. His upper store was torn down in the 1990s to make way for a new railroad overpass and the reconstruction of the Black Point and Highland Avenue intersection. The Prouts Neck store still stands and operates as a seasonal gift shop and post office.

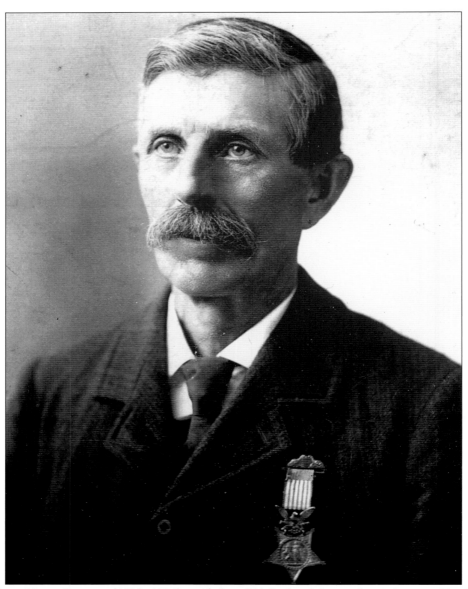

William Hayes Googins (1838–1926) resided in Old Orchard during the early part of his life. In 1880, he came to Scarborough and eventually purchased a home at 441 Black Point Road. A carpenter by trade, he worked in the Prouts Neck area. His home, at the corner of Ferry Road, still stands. During the Civil War, Googins was a member of the 27th Maine Regiment. That regiment was noteworthy because every member was awarded a Congressional Medal of Honor, the "highest award for valor in action against an enemy force which can be bestowed upon an individual." Some 300 members of the 27th, including Googins, volunteered to defend Washington, D.C., even though their enlistment had expired. In return, Secretary of War Edwin Stanton submitted the entire group for Medals of Honor. In 1917, a review board revoked these medals. Googins is shown later in life with his medal, which is still in the possession of his family. The story of the 27th Maine Regiment and the Medal of Honor were documented in a book by John J. Pullen called *A Shower of Stars*.

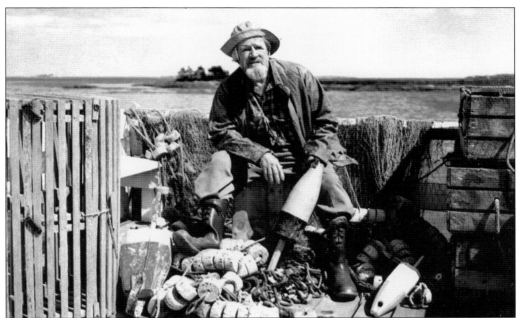

"Many's the stories he could tell of years of sea wind and salt spray, summer's heat and winter's icy blast on the Atlantic coast. Survivor of a past age, he still maintains his proud independence with dory, lobster trap, and net." This postcard has been published countless times during the past 60 years and may be the most widely circulated Maine card ever produced (above). The "old salt" was Fred Latham. He never went to sea. He was a drifter who would do whatever came his way to earn his keep. For two summers, he lived in an abandoned Model T Ford in the pasture of the author's grandfather. He often dressed as the old salt and posed for artists or cameramen. He eventually erected a tent and tarpaper shack on the marsh near Seavey's Landing Road, where he is shown in a photograph labeled in his own hand, "Prince Frederick of Eutopia" (right). Well-educated and from a successful family, he simply chose an alternative lifestyle. (Right, courtesy of Harrison Smith.)

Native son Fred M. Newcomb (1859–1920) was in business here throughout his life. His name is synonymous with the history of Scarborough c. 1900. He kept a general store near Scarborough Beach Station and a summer store at Prouts Neck. His store near the station is still occupied by a small business. A member of the board of selectmen, he served six terms as its chairman. He was postmaster for 17 years. In 1916, he was elected to represent Scarborough and Cape Elizabeth in the state legislature. He belonged to the Congregational church and served as its treasurer. He was an active member of the Masons and the Knights of Pythias. Many of his descendants live in town today.

It was not uncommon to see stage and film actor Gary Merrill in Scarborough. His aunt had a cottage at Prouts Neck, and he came here from an early age. During his career, he made 42 films. His most productive years in Hollywood were in the 1940s and 1950s. His most critically acclaimed film was *All About Eve*, which he made in 1950 with legendary film star Bette Davis. Merrill was married to Davis during the decade of the 1950s. The couple had a home in Cape Elizabeth called Witch Way. Here, they are shown during a happy moment in what was, by all accounts, a stormy relationship. Late in his life, Merrill wrote an autobiography called *Bette, Rita and the Rest of My Life*.

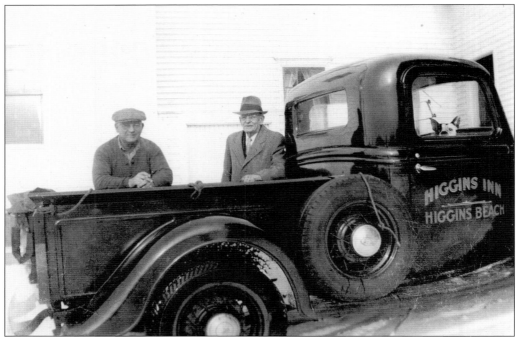

Jesse H. "Skip" Newcomb (1886–1960) and Ed Higgins (1872–1958) were two local businessmen and friends. Newcomb (left) was a successful market gardener. His farmhouse still stands at the corner of Spurwink and Marion Jordan Road. Higgins developed Higgins Beach and started two small businesses there: the Higgins Inn and, later, the Conora Restaurant. (Courtesy of Mary Lello.)

Linwood R. Higgins (1922–1962) was a Scarborough native who established a company still well known in this area. He served in the army during World War II and afterward established an excavating and paving business called L. R. Higgins. That company now specializes in waste management services. (Courtesy of Rachel Higgins Demers.)

SCARBOROUGH TOWN COUNCIL

E L E C T E L E C T

DONALD J. CLARK

VOTE FOR EXPERIENCE!
THE RECORD SPEAKS
FOR ITSELF

HAS SERVED AS FOLLOWS:

* TOWN CLERK * TOWN TREASURER
* MODERATOR * SELECTMAN
* SCHOOL BOARD * TOWN COUNCIL

* STATE LEGISLATURE

YOUR SUPPORT ON NOV. 4, 1986
WILL BE APPRECIATED

Come on Rod: I need some help! Lets get "cracking" Thanks Don Clark

Donald Clark (1920–1988) was born in Whitefield. His family moved to Dunstan when he was young. Clark graduated from Scarborough High School and served in the navy during World War II. He and his wife, Isabel Harmon, lived on Black Point Road. His wife was employed at town hall for many years, and Clark was active in state and local politics throughout his life. He served in the 99th state legislature and held almost every elected position in the town of Scarborough. He was honored by the Chamber of Commerce of Greater Portland with the Neil W. Allen Award for distinguished leadership in the public sector.

Wanting to be prepared, John Scott Pillsbury digs his own grave in Dunstan Cemetery. This photograph was picked up by the Associated Press and appeared in newspapers in the United States and Europe. The headline read, "Man of 80 Digs His Own Grave." Pillsbury lived for a year after this photograph was taken in 1949. (Courtesy of Peter Bachelder.)

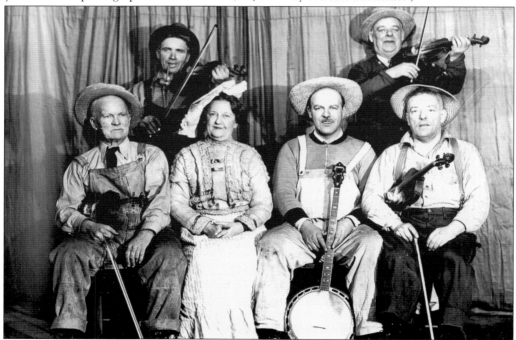

Calling themselves the Barnyard Rubes, the members of this group were from the Pleasant Hill area. They performed at many local functions. From left to right are the following: (front) Col. Charles Nutter, Julia Maney, Robert Nutter, and Chester Mitchell; (back) A. Jasper Willey and Louis Chandler. Taken at town hall, the photograph dates from c. 1930. (Courtesy of Marilyn Page.)

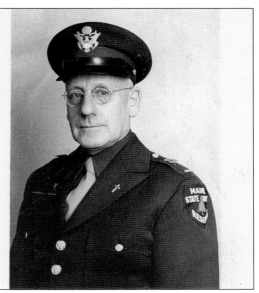

Greetings
of the Season
and all
Good Wishes
for
Your Happiness
in the
New Year

A native of Massachusetts, Rev. Rencel Colby (1882–1952) was minister at the Black Point Congregational Church from 1913 to 1928. During World War II, he served as a reserve officer. He lost his only son in the war. On the reverse of this 1943 Christmas greeting he wrote, "Don't you think I look more like a Major General than just a Chaplain. Ida (his wife) says I am not nearly as fierce as I look."

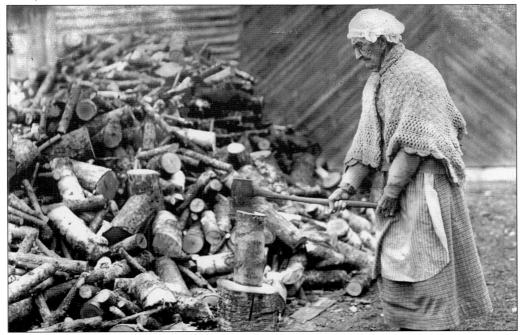

Mary Waterhouse of Scarborough splits wood on her 102nd birthday in 1927. A news article from the following year records her ride in an airplane at the Scarborough Airport. She was accompanied on that flight by two other centenarians. Town records indicate that she lived 103 years, 6 months, and 23 days.

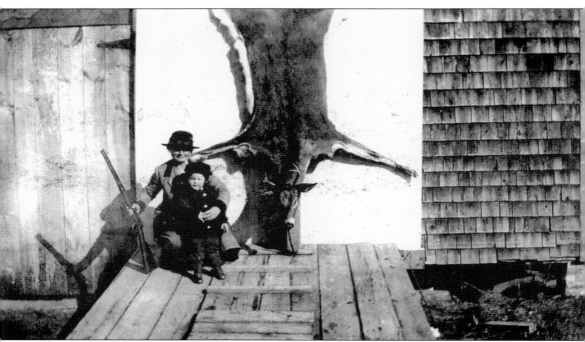

In the fall of 1920, deer were scarce in North Scarborough. Harry Meserve, who lived in the Coal Kiln neighborhood, left the area to try his luck elsewhere. His sister Mattie Brown (1882–1968), who also liked to hunt, did not accompany her brother on this particular trip because Meserve and the other men in the party had planned a full day and decided it would be too difficult for her to keep up. Thus, she was left behind to do the chores and keep house. At midday as she went out to the barn, she saw a buck in the overgrown field across Saco Street. She got out her Winchester, loaded it, and dropped the deer with a single shot. Later that day when the men retuned home empty-handed, she prepared them fresh deer liver for their supper. The event was captured on this postcard view. With her is two-year-old Frances Knight Marsh. (Courtesy of Peter Bachelder.)

Eight

INTERESTING
PHOTOGRAPHS

While Dick Fowler works in his cornfield in 1997, new houses rise behind him. Scarborough led the state in new-home starts in the last quarter of the century. Over the past 100 years, the town's economy has shifted from one almost totally based on agriculture to one with only a few families who still make their living from farming.

Located in the vicinity of the Co-op on the back shore at Pine Point, this summer cottage had an unusual beginning. It was originally constructed as a houseboat. As it never proved to be very seaworthy, it was eventually hauled ashore. At the time this photograph was taken, the cottage was owned by Mildred Boff. (Courtesy of Kaler Vaill Home.)

In today's society, little thought is given to winter food supply. Grocery stores provide a variety that is beyond the wildest dreams of early Americans. Before being put into cold storage or shipped to market, winter vegetables at the Foss farm on Black Point Road were allowed to "harden off" for a few days c. 1910.

It was not until the 1870s and the influx of summer tourists that scenes like this appeared along the shore in Scarborough. Life was demanding for local youth, as they were the most physically capable. Little time was spent on recreation, especially in the summer months. These young men are at Prouts Neck. The West Point Hotel is in the distant background. The photograph dates from *c.* 1900.

This classic scene is repeated each summer along the coast of Maine. Visitors return to renew old friendships and exchange news of the past year's events. In this case, Mrs. Little and Mrs. Warren share the day on the porch of the Atlantic House in 1951. The image was captured by noted photograph artist Dorothy Warren.

Scarborough is noted for its fine sandy beaches. However, like most of the coast of Maine, it has rockbound shores as well. This area known as Thunder Cove lies between Higgins Beach and Scarborough Beach. The crashing waves sound like thunder because the rock face is particularly sheer in this spot. (Courtesy of William Torrey.)

Bill Googins (left), Robert Jordan, and young David Pratt rest beside a newly erected sign on Stratton Island. In 1958, the island was privately purchased and then deeded to the National Audubon Society in memory of Phineas W. Sprague. The gift of this island preserved it as an important natural habitat. Hundreds of seabirds nest here each summer. Stratton and Bluff Islands are located some two miles off Prouts Neck.

In August 1958, members of the Libby Homestead Association unveiled a memorial stone in Black Point Cemetery. It was dedicated to the memory of Scarborough's early settlers. The stone was taken from the John Libby Homestead. John Libby was the first European with the Libby name to emigrate to New England in the 1630s. He settled in Scarborough. All of the Libbys in America are believed to be descended from him. (Courtesy of Robert Lindquist.)

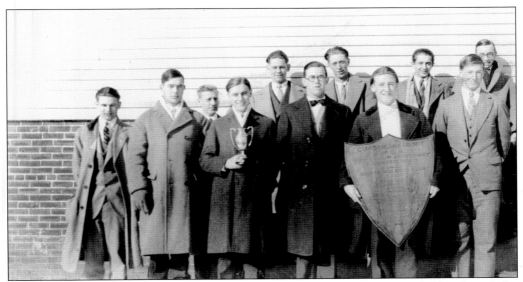

The Scarboro Boys Club was sponsored by the Black Point Congregational Church and the Young Men's Christian Association (YMCA). From left to right are Walter Frederick, Clyde Harmon, Rev. Rencel Colby, Fred Skillings, Clayton Urquhart, Max Emmons, William Googins, Maurice "Bud" Libby, Willard Frederick, Eldred Harmon, and Stanley Harmon. The photograph was taken in 1926.

One of the town's oldest church structures is located in North Scarborough near the Buxton line. Built in 1839, the First Universalist Church is at the far end of the Broadturn Road at an intersection commonly known as Scarborough Corner. When the church was built, each family purchased its own pew. Actual deeds were drawn for the pews, which could be passed from one generation to the next. The money collected helped finance the construction. To this day, the pews still have their hinged doors, an old custom that most New England churches did away with long ago. Since the original church was unheated, parishioners had to bring their own source of warmth in the coldest months. This usually consisted of flat stones that were heated at home and then placed in a metal-lined wooden box that had a handle. At church, the box was placed on the floor and the parishioners put their feet on it. A detached parish hall, known as the Bungalow, was constructed in 1914. Today, the Bungalow is rented for functions by a group of preservationists who are working to raise funds to restore the church, which has not had an active congregation since 1972.

A landmark tree that once stood on Dunstan Landing Road was known as the King Elm. It was on property once owned by the famous King family. The tree was lost to Dutch elm disease in 1960. Every effort was made to save it, including injections, pruning, and spraying. At the time it was taken down, the tree was six feet across at the base and estimated to be 300 years old. The millstone in the foreground is still there. It honors William King, Maine's first governor. (Courtesy of Town Archives.)

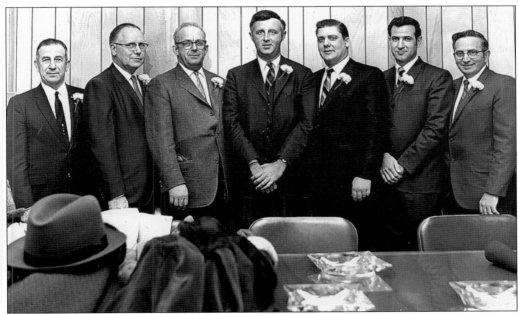

The year 1970 was the first in which Scarborough had a council-manager form of government. The first councilors are pictured at their formal swearing-in ceremony. From left to right are Ralph Lorfano, Oscar Teravainin, Raymond Wiley, H. Davison Osgood, Harry Knight, Marshall Goodwin, and Norman Bushey. Knight was also Scarborough's representative elect to the state legislature. Tragically, he lost his life in a house fire in December of that year. (Courtesy of Town Archives.)

In 1883, a town hall was erected at Oak Hill. Originally, there was a large meeting room with a stage on the first floor. Some of the first high-school classes were held in the two rooms upstairs. In 1915, a brick vault was added, along with a meeting room for the selectmen. (When this building was demolished, the author salvaged the vault door and frame.) During the Depression, the Work Projects Administration (WPA) further expanded the building by adding two wings, one on either side, visible in the 1950s view (above). The structure was badly damaged by fire (below). The exact details and year of the fire remain unknown. High-school proms, class plays, and graduations were held here through the 1940s. After 107 years of service, the structure was taken down when the town opened its new municipal building in 1993.

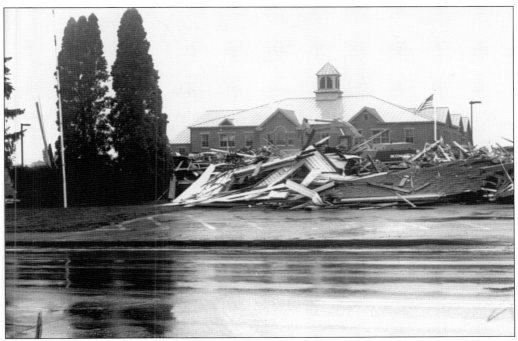

Scarborough's new municipal building rises behind the rubble of the old town hall. The new building project was controversial in the late 1980s, when it was in the planning stage. However, in light of the town's rapid growth, the old town hall certainly would have been inadequate to meet the current demands of the citizens.

DOG LICENSE.

Registered No. 47 Amount of License $ 1.15

OFFICE OF CLERK OF *Scarborough*

License is hereby Granted to *S. Pederson*
of *Scarborough* for a male dog, of *Black* color,
breed *Shepherd* ..., aged , and named
Frithiof , to run at large until the first day of April, 1895 next,
subject to the provisions of the statutes in such cases made and provided.
Given under my Hand, this 16 day of *April* A. D. 189 4.
......... Clerk.

N. B. Every dog except those covered by a special kennel license, must wear around its neck, a collar distinctly marked with the owner's name and registered number. The Law makes it the duty of City and Town authorities to cause all dogs within the City or Town not so licensed and collared, except those aforesaid, to be destroyed under warrant issued within ten days after May first.

THOMAS B. MOSHER, STATIONER, PORTLAND, ME.

This dog license was issued by the town of Scarborough to Selius Pederson of Highland Avenue in 1894. It was issued on a form used by towns throughout the state. At that time, state law mandated that any unlicensed dog could be picked up and destroyed. This must have given dog owners great incentive to license their dogs.

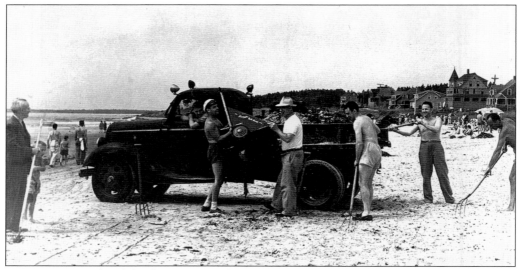

Decaying seaweed and the flies it attracts have never been popular with the thousands of people who use Scarborough's beaches. Today, the citizens of Higgins Beach rake the beach each Thursday morning, and the town handles the disposal. It is an all-citizen effort in 1939, as Bert Kenney sits in his truck while it is being loaded. (Courtesy of Dan Warwick.)

Waldron's Garage was located on Route 1 near the entrance to Haigis Parkway. Many wrecked cars were taken there and placed in public view. Fathers often took their sons to see the demolished vehicles for a lesson on the dangers of reckless driving. This GTO convertible was involved in a double-fatal accident on Pleasant Hill Road in August 1968. (Courtesy of Scarborough Rescue.)

NOTICE

To the Inhabitants of the Town of Scarboro, Maine:

We, the local Board of Health and Overseers of Poor of Scarboro, Maine, give this notice, notifying and compelling all persons in said town who have not been vaccinated within the past three years to do so before March 1st, at the expense of said town.

Such assistance can be had at the office of DR. B. F. WENTWORTH, Oak Hill, from 12 to 1 o'clock p.m., and from 6 to 10 o'clock p.m.

We also request that no public gatherings be held in said town until further notice from the local boards of Scarboro.

B. F. SEAVEY, Chairman,
B. F. WENTWORTH, M. D., Sec'y,
M. I. MILLIKEN,
} Board of Health.

J. S. LARRABEE, Chairman,
O. F. MILLIKEN,
T. H. KNIGHT,
} Overseers of the Poor.

Smallpox was a potentially fatal infection that was known to be spread by air and not by water. This prompted health officials to ban public meetings during times of potential outbreaks, as evidenced by this broadside. The *Town Report* for 1903 reflects the cost to the town for the vaccination drive of the previous year. Smallpox was officially declared eradicated worldwide in 1980. (Courtesy of Scarborough Historical Society.)

Large billboards like this one on the Scarborough marsh were a common sight on major roadways throughout Maine. The state outlawed this style of advertising in 1977. The blockhouse information center is also visible in this 1974 photograph. (Courtesy of Scarborough Historical Society.)

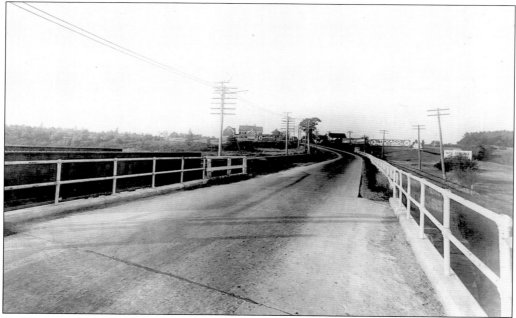

Today, it seems impossible that Route 1 could ever have appeared like this during any daylight hour. Looking in the direction of Portland, the view shows the Nonesuch River bridge. The houses in the distance are near the intersection of Pleasant Hill Road. Note the slightly elevated trolley tracks and separate bridge (left). The photograph dates from *c.* 1930.

NIGHT·CAP PARTY,

AT GOOD TEMPLARS' HALL,

DUNSTAN,

Tuesday Ev'g, Nov. 14

FOR THE BENEFIT OF

SCARBORO' BAND

CLAM STEW

Will be served Free to all wearing Night-Caps.

ADMISSION 15 CTS.

If stormy it will be Wednesday.

BIDDEFORD JOURNAL JOB PRINT.

The Good Templars were a temperance society with chapters worldwide. The prohibition movement was strong in Maine. The Templars' national leader, Neal Dow, was a Portland native. In Scarborough, the Templars erected a meeting hall in Dunstan Village. It was located where the Soldiers Monument now stands. Eventually, the building was moved farther south on Route 1. Today, it is the Governor William King Lodge of the Masons. This broadside, which would have been displayed in a public place, promised free clam stew to all those who showed up wearing a nightcap.

Recycling is considered a relatively modern concept. The people of Black Point gathered this material to recycle for the war effort during World War II. Steel and rubber were two items that were in short supply. The site was at 238 Black Point Road, on the property of Elva Harmon. If you found this book interesting, recycle it by passing it on to others. Share the story of Scarborough, a dynamic town on the coast of Maine.